THE COLOURS OF
THAILAND

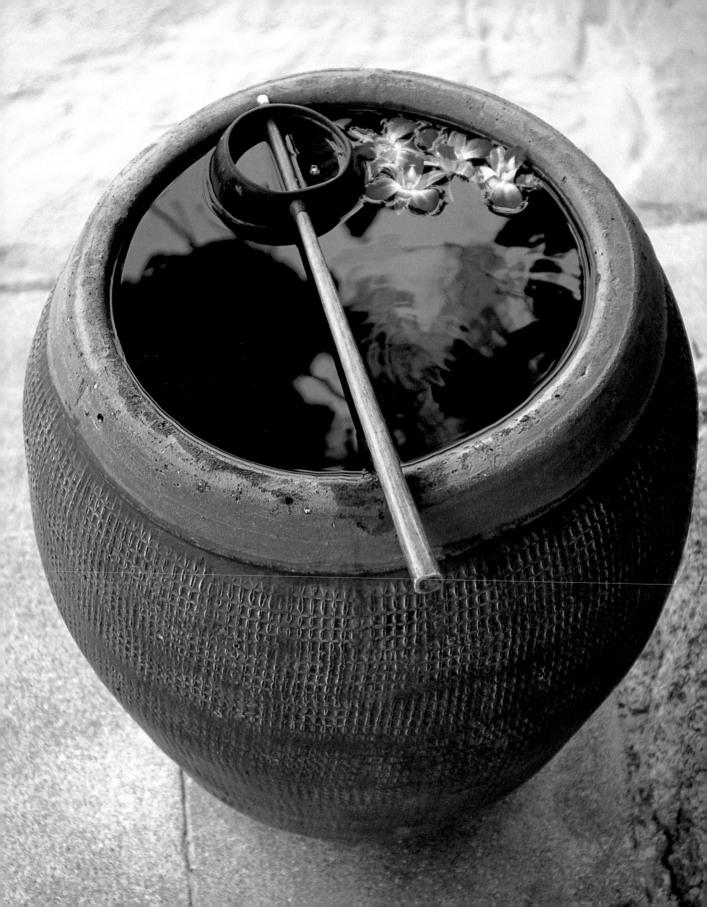

THE COLOURS OF
THAILAND

BARBARA LLOYD

WITH 185 COLOUR ILLUSTRATIONS

THAMES AND HUDSON

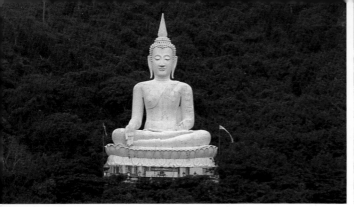

For Tessa, with love

Acknowledgments

I AM DEEPLY INDEBTED to the following people: Mrs Sumontha Nakornthab, Director of the Tourism Authority of Thailand's London office, whose help and support from the outset has been invaluable; Thomas Neurath for suggesting the idea; Katrina Clements, of Asia World, London, and Sirinipa, of East West Siam, Bangkok, for organizing my very complicated itineraries; and Lisianne Belton for her introductions. Thanks also to the various guides who helped me – I would like to remember especially Sudjai Tongpinhochai (Phuket Office) and Kongburi (Chiang Mai Office), who made those particular legs of my journey enjoyable. Bum and No, who did most of the driving for over 7,000 kilometres, deserve appreciation. I am grateful to the Director of the Philatelic Division of the Communication Authority of Thailand for permission to reproduce six stamps.

Finally, many of my photographs could not have been realized without the beautiful and kind people who have unwittingly become my models. I would like to thank them too.

British Library Cataloguing-in-Publication Data

A catalogue record for this book is available from the British Library

ISBN 0-500-27930-6

Printed and bound in Hong Kong by South Sea International Press Ltd

Contents

Title page Waterbowl with lily

Above, left to right Seated Buddha near Nakorn Ratchasima; detail from the plinth of a gilded *garuda* (temple guardian); tomatoes and chillies; looking down to the beach at Prachuap Khiri Khan

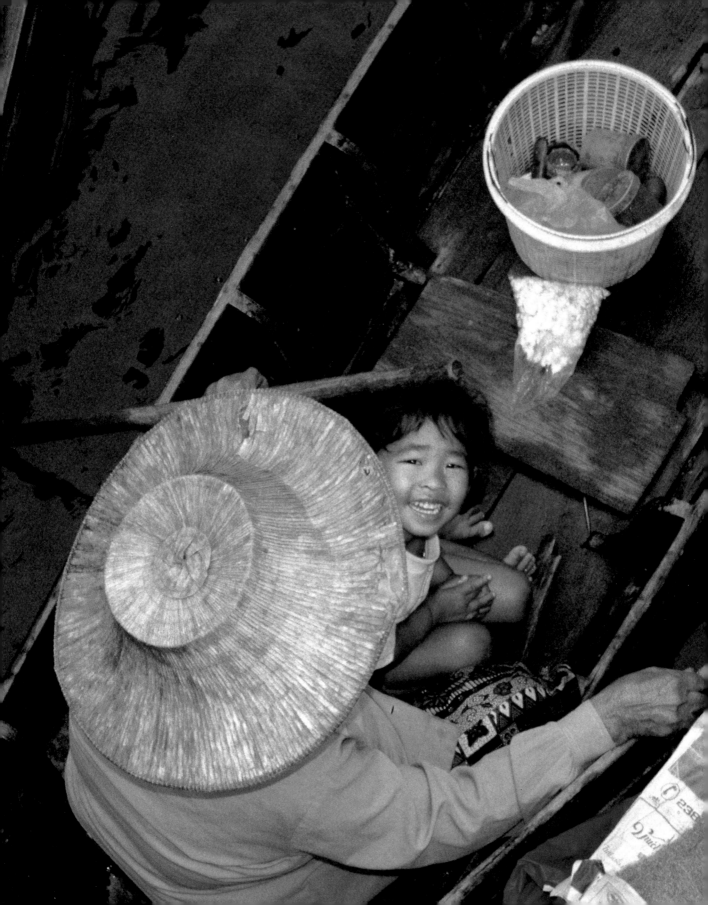

Foreword

Brilliant gold and saffron – these are the two colours that greet the first-time visitor to Bangkok, capital of the Royal Kingdom of Thailand. They are colours that characterize the gilded roofs of the temples and the bright robes of the monks. Amid the noise, the traffic, the pollution and the sheer physical effort of making progress through the city, the vibrancy and depth of colour all around stimulate the senses.

The first sight of Bangkok is impressive: the elevated highway slices through the modern downtown skyline – this city the dream of architects young and old. Shanty towns and small old buildings are completely overshadowed by extraordinary structures reaching for the sky. Bangkok's super-luxury hotels now dominate what was once Chinatown. Among others, the Oriental and the Royal Orchid Sheraton hug the riverside, giving wonderful views. The spectacle of life on the waters is part of Bangkok's charm – multicoloured cigar-boat river

taxis emblazoned with weird snakes and dragons shoot past, raising waves on the Chao Praya's murky brown waters. Public transport buses pass by, and ponderous black rice-barges slowly make their way downstream from Thailand's furthest corners. They are often decorated with red and orange, or multi-coloured abstract geometrical images to ward off evil spirits. This constant traffic forms a ceaseless to and fro of humanity and cargo. Children dive off the porches of their riverside homes into the canal waters, gambolling and splashing. It is a vibrant scene of life and colour. Commuters use the river to get to work, cross-river ferries desperately avoid the larger motorized traffic that raises great swells. This may be the 'Venice of the East', but the scale here is much larger.

Further downriver is the complex of the Grand Palace and Wat Phra Kaew, the focal point of so many tourist visits to Bangkok. *Farangs* (foreigners) and Thai visitors alike throng this vast network of buildings. Gilded *garudas* (temple guardians) hold court –

strangely enigmatic creatures, some male, some part-female and part-bird. Soaring golden and inlaid spires reach for the skies. Many *garudas* are decorated with thousands of mirrors; and mirrors adorn many walls, so that the marble floors and golden roofs refract the coloured lights, creating hundreds of mini rainbows. What a wonderful, magical place this is! It is the first taste of the splendours of the older capitals of Siam that lie to the north and east of Bangkok.

Nearly every Thai male will spend at least two weeks of his life in a *wat* (temple-monastery). In this way, he will earn merit for his afterlife – just as merit is earned by honouring one's parents, and by observing certain rites in the temple and at home. If a novice monk decides to take the cloth, his family too will gain great merit. The discipline is tough – rising before dawn to beg for alms and food, monks can be seen strolling the streets barefoot in the dim light with their collection bowls. They may eat only once a day, before noon, and they must both adhere to 227 monastic precepts and renounce worldly goods. There are about 32,000 monasteries in the country, and at least 200,000 fully ordained monks who are scholars or teachers. No wonder the saffron robe is such a common sight. Monks' robes are not all the same shade of yellow: the saffron typical of a Bangkok religious man will be a deeper, brownish hue if he is originally from the north. Monks from Myanmar (Burma) wear an almost reddish cloth, as do some rural recluses. The spectrum of cloth ranges from the near-canary yellow of modern quick-drying fabrics to luscious golds, deep ochres or ambers and rich earthy siennas. Some monks are very famous and renowned for their

good works, drawing large crowds of disciples. The *wats* they inhabit are complexes built to specific standards – with *viharns* (assembly halls), *chedis* (reliquary monuments), *salas* (meeting rooms) and, most important, the *bot*, where new monks are ordained. Every complex is built around a holy pool.

Far older than Buddhism is the Thai belief in spirits – both god-like and embodied in objects (animist). They take many forms and have many purposes, guarding land, home, village or special sites. All spirits must be placated – 'spirit houses' stand guard at every *wat*, home, hotel or shop. These residences, traditionally wooden, but today mass-produced in plastic or concrete, assuage the *phra phum* (earth spirits), or *phi*, as they are called generally. Ancestral figurines, candles and offerings of food and drink adorn these charming miniature edifices. At night many are lit up with flashing fairy lights.

Most visitors will head north from Bangkok via Ayuthaya and Sukhotai to the cities of Chiang Mai and Chiang Rai which are so refreshing after the bustle and pollution of the capital. Ayuthaya, capital from AD 1350 to 1767, was recently declared a Unesco World Heritage National Site. Partially submerged by flooding in the autumn of 1995, the desperate scenes of devastation here and in the central flood-plains were heartbreaking. Sukhotai was the first capital of the Siamese Kingdom, flourishing just before Ayuthaya, and is considered the centre of the Golden Age of Thai civilization. It must have been extraordinary in its full glory, for even today it is certainly awe-inspiring. It is the scene of the joyous

Loy Kratong Festival, which celebrates the November Full Moon Solstice. This is a time for families to share prayers and launch floral floats with lighted candles into rivers and ponds at night as gifts to the water spirits, with a prayer for good luck and health.

Chiang Mai and Chiang Rai are the launching pads for treks and visits to the hill-tribe settlements and northernmost provinces and, of course, to the famous Golden Triangle. This name refers to an area bounded by the borders of Thailand, Laos and Burma and the Mekong River; the river forms a natural boundary with Laos for some of its course. In the Triangle, at the height of the dry season, it is no more than a narrow trickle running through the river bed's deep ochre banks. During the rainy season, however, it runs thick and muddy and brown. Originating in China, the Mekong will finally flow into the Mekong Delta in Vietnam.

In the Golden Triangle is the greatest conglomeration of hill tribes – many living rather sad lives in exile. Refugees from Myanmar, Laos, Tibet and China, they eke out their existence often just across the border from their old homes. Mainly animist by faith (believing that plants and inanimate objects have souls), they have great charm, and those who are used to *farangs* will happily pose for the camera, and sell crafts typical of their tribe: the Akha, bedecked with silver balls and coins and beads; Lisu, who wear beautiful blue and pink tunics over trousers, and occasionally black turbans with tassels; and Yao

women, who wear rather formal black turban-like headdresses, which are lengths of cotton wrapped around the head, becoming wider at the top, while their jackets are intricately embroidered with bright threads – pinks, purples, deep blues and turquoise.

The Red Karen is perhaps the most famous of the hill tribes: this is the 'giraffe neck' tribe. Girls born on specific days of the month are entitled to wear rings on their necks, wrists and ankles – as they mature they add more rings and are entitled to a better status in their village. The Myanmar army regularly persecutes these villages just across their border, as all the Karen men are engaged in fighting against the government full time.

Where the hills have not been devastated by the hill tribes' 'slash and burn' farming techniques, lush and verdant forests cover the higher slopes, while vivid green rice paddies interspersed with small villages dot the landscape. Thai bullocks, often a strange pink colour, are still the poor man's main beast of burden and agricultural aid. The area in the northeast, an area of great beauty which includes Isan Province, is now being promoted as the 'Green Triangle'. Here the Mekong sweeps along in a mile-wide swathe – and here, too, is the site of yet another Festival – that of the Illuminated Boats. Held at Nakorn Phanom, giant bamboo boats are constructed and bedecked with simple lights – old bottles filled with petrol that burn for a few hours. These edifices are released onto the river in the dark and form a

wonderful picture as they float past serenely in the night. Rich and green during the rainy season, the land will only support one crop in the hot period so many men will go to Bangkok or other big cities in order to earn cash to send back to their families.

Near the border with Cambodia are some of Thailand's most exquisite Khmer ruins: Prasat Phanom Rung, Prasat Muang Tham and Khao Phra Viharn. This northeastern area is filled with wonderful examples of the Khmer period. There is another happy Festival here too – the Surin Elephant Roundup. In years gone by, wild elephants would be corralled and tamed while dignitaries observed from a safe distance. Today it is re-enacted, as there are hardly any wild elephants left. In this area are villages whose livelihood still depends on the elephant. Nearby Prasat Hin Phimai, an eleventh-century Angkorian ruin, is well worth a visit and is a prime example of the Thai Fine Arts Department's restoration programme.

Most visitors to Thailand will end their trip with a holiday somewhere in the South, and for me the Southern Peninsula and its islands are the most enchanting, unspoilt area. The resorts of Cha Am and Hua Hin are particular favourites of the Thais, and are completely different to the resorts favoured by *farangs*. Hua Hin is just 180 kilometres from the city and was popularized by Prince Chakrabongse, a brother of King Rama VI, in about 1910. Thais at rest prefer to lie in the shade of the giant casuarina trees that line the beaches. Equipped with food vendors' fare or picnics, they consume beer or whisky, soft drinks and bottled water. They cool off by paddling in the shallows or swimming partially clothed as protection from the sun – no sunbathing here! The beaches are packed, while cars, motorbikes and bicycles, as well as the handpainted multicoloured 'tuk-tuks' and 'samlors' (both public transport), ferry holidaymakers about. As ever, there is a lot of noise, with ghetto-blasters

blaring out favourites. They are a rowdy and happy people. At day's end the roads are choked with weary daytrippers heading home.

Phetchaburi, Prachuap Khiri Khan and Chumpon on the southeastern coast are unchanged by the effects of mass tourism, retaining a natural charm. Here are still to be found the traditional Thai wooden buildings and *wats*. The waterways are still relatively clean, and life along the riverside seems as if arrested in time. A climb up to the *wat* perched high above Prachuap Khiri Khan is worth the 480 steps to look over the gleaming dome and *chedi* down across the clear blue sparkling and serene waters of the bay to the Gulf of Thailand. Wicked little brown monkeys, like wizened old men, clamber over its brilliant dome, creating dark blots on the golden surface.

Surat Thani is a stopover town for those heading towards Ko Samui with its glorious beaches, luxury hotels and guest houses. Only thirty-five years ago the island was totally undeveloped, depending on coconuts as a cash crop. The coastal coconut plantations are gradually being eroded by development – although inland the estates remain intact. A day's round trip from Samui, Ang Thong National Marine Park is a magical area of islands with characteristic limestone outcrops, blue lagoons and sandy beaches. Snorkelling and scuba diving are very popular here.

Phuket off the west coast is a more favoured resort island. There are many stunning luxury hotel developments as well as the usual tourist accommodation. Sadly, the high-rise condominiums at Patong are eyesores and the popular beaches are getting spoilt. Many beaches that were used by Thais are now out of range of the locals' pockets. The Andaman Sea is beautiful – the waters are warm and almost sweet. There is a large community of *chao le* (sea gypsies), who are purported to have come by sea from the South Sea Islands, and who certainly bear some physical resemblance to

those people. Kick-boxing stadiums abound, and a night viewing this extraordinary sport is exciting. In the fiercely lit brightness of the arena, which contrasts with the gloom of the surrounding seating area, the contestants' polished gloves shine proudly. Red and blue are favourites – coloured headbands add to the richness of the tableau. Neon lights lend a gaudy atmosphere. The steady beat of traditional Thai boxing music adds to the excitement. The boxers are athletes of great agility – often mere boys who perform their art with skill and dexterity to shouts and cheers from the predominantly male audience.

While Phi Phi and Phang Nga Bay's 'James Bond' island (so-called after featuring in *The Man with the Golden Gun*) are very beautiful, they have become tourist traps. However, a long-tail boat trip in the early morning in Phang Nga Bay to see the weird rock formations looming out of the sea is a great experience. The deep mangrove swamps conceal several villages that perch on stilts above the saline waters. The gentle swishing of the oars of a long-boat mysteriously sliding out of the watery, green forest can take you by surprise. Ko Pannyi hosts a fair-sized Muslim village also perched on stilts, whose people live off fishing and tourists on their way to 'James Bond' island.

The further one travels down the Southern Peninsula the more unspoilt the country seems. There is an inland sea, Thale Sap Songkla, where life goes on undisturbed by mechanization – with the exception of motorized long-boats. This brackish water is heavily fished, with black tiger-prawn the main catch. The intensive fishing techniques employed are ultimately going to ruin the ecology of this area of natural beauty. In the still of these waters, the passing of our boat echoes eerily amongst the grasses. Disturbed by the noise, great clouds of waterbirds lift up from the lilypads and waters, darkening the sky as they fly past. Waterlilies and reeds give shelter to some 180 species of wild birds, including the nearly black *nok i kong* with its wobbly legs, the redheaded brown *nok pet daeng* duck, white egrets and oily cormorants. Gatherers of swallows' nests guard their territories greedily – for a great part of the year their home is a bamboo platform just above the high-water level.

Near Trang we went to a bullfight. *Not* what we are used to from Europe and South America, this is quite different: it is non-violent. The contestants are hump-backed bullocks, prize fighters, lovingly cared for and trained. They are taken for walks on the beach, to strengthen their legs. They are paraded around the ring in pairs, docile on the end of their tethers. When their faces have been smeared with banana and doused with whisky, they are let loose on each other. They butt their heads together and the first to retreat is the loser after much pushing, grunting and snorting. Great wads of money are wagered – tens of thousands of *bhat*. The audience – mostly men, but nowadays also women – shout themselves hoarse. Thais love sport and competition. They adore every conceivable kind of fight and pitch together pairs of fish, scorpions, snakes and cocks. They are passionate about boat racing, football played with hollow bamboo balls, *muay thai* boxing and swimming.

There is an old town near the port of Songkla in the southeast that is still full of charm, with wooden houses that have survived modernization intact. Just outside the town is a Muslim fishing village where a small fleet of the painted *kaw lae* (traditional fishing boats) is moored. A style typical of Malaysia, where many of the fishing population are supposed to have originated, the boats are adorned with beautiful paintings of dream islands or homes by the sea. Each boat has its own unique colour scheme and design – blues and yellows, red and orange, green and white. The combinations are endless and the results truly beautiful works of art. During the daytime, these

boats' precious adornments are protected from the sun by palm frond shelters. They are lovingly repainted every year.

The southernmost provincial capital Yala is surely the cleanest city in the country. Only here are the streets free of litter. Now the centre of the national rubber industry, it seems hard to believe that the first rubber trees were only introduced about ninety years ago. They were brought from Malaysia which had recently imported saplings from South America, and after sugar and pineapple, it is now Thailand's principal export. Yala has a busy market peopled with beautiful Muslim Thai women wearing bright multi-coloured clothes, as well as the traditional white headcoverings (certainly not black here), their dress as colourful as tropical birds and competing with the colours of the produce on their stalls.

Some 120 kilometres west of Yala, a treacherous mountain track takes the determined traveller to the home of the last indigenous tribal Thais. These are the *Ngaw* people – also nicknamed 'rambuttans' (after the fruit) because of their spiky hair. Very few in number (about 30 in total), they inhabit a serene spot with running water, and plentiful food in the forests beyond. Hunter-gatherers and animists, they are protected and supported by the government, which also runs a school there. Slightly negroid in appearance, they are supposedly direct descendants of the Proto-Malays – an aboriginal pygmy-type race found in the Philippines, New Guinea and parts of Africa.

The beaches on both the southwestern and southeastern coasts run almost uninterrupted down to the border with Malaysia, lined with coconut palms and casuarina trees. Many areas are still untouched by the relentless march of tourism and development. The small fishing village of Panare is worth visiting to see the veritable flotilla of painted boats lying on the sands. The juxtaposition of the multicoloured hand-painted boats against the gleaming white sands and serene blue of the sea justifies the detour.

Every visitor to Thailand may enjoy the vast selection of food that is available. Food freshly cooked on the streets and bought from vendors is the most popular with the Thais themselves. During my travels the variety of produce that I found in the markets was extraordinary and my fascination with this will be apparent in some of my photographs. Thai food can be, quite simply, a work of art. Vegetables and fruit are sometimes carved with love and pride into beautiful designs. In the market and at table, displays are spectacular – from catfish ready for cooking to mangoes and chilli peppers – every stall a riot of visual effects. No corner of the palette is left untouched – lychees, melons, rambuttan, durian, beans, garlic, lemongrass, zucchini, ladies' fingers, the weird pinks and greens of rice- and tapioca-based sweets, and the cool white of home-made rice noodles.

The Thai's very essence is calm and collected, passionate yet submissive, and deeply religious. These contrasts are expressed in a profusion of visual experiences which make for unforgettable images: the temple complexes with their gleaming golden domes and elaborate and extraordinary topiary; multifaceted deities reflect the sun from their surfaces in rainbow cascades of light. The officers of the Buddhist faith silently glide through life wrapped in their saffron robes, emanating inner peace and tranquility. The luxurious green of the ripe rice harvest contrasts with the deep rich ochre of the northern territories' mountains and river beds. And everywhere, there are clear blue skies with magical powder-puff clouds.

All of these experiences enhance the pleasure of travelling in Thailand. I am greatly indebted to the many Thai people I met on my travels who helped me in the achievement of this work.

BARBARA LLOYD

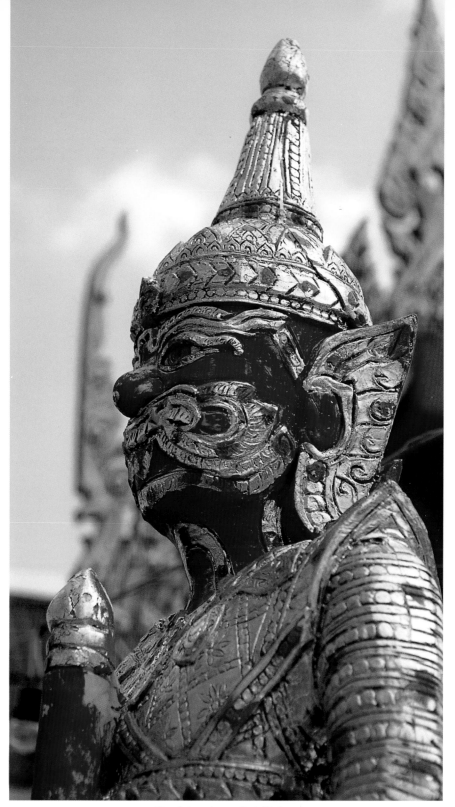

Garuda (temple guardian), Ko Samui

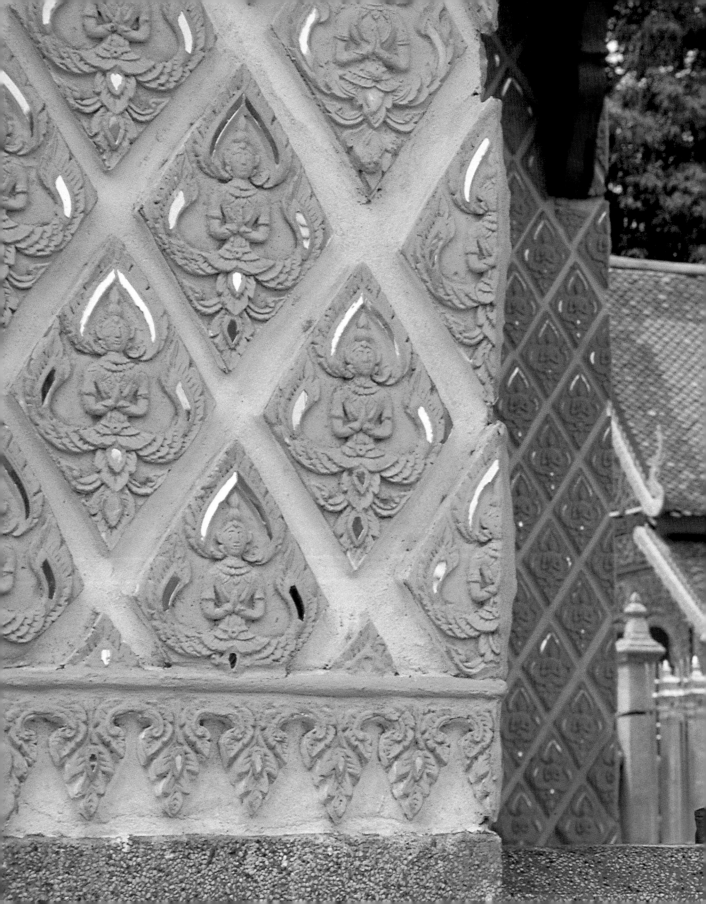

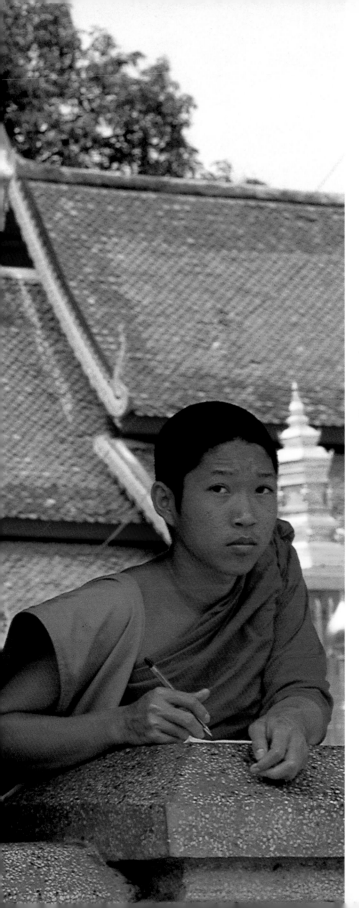

I.

Saffron

T HE STIGMA of the crocus flower – painstakingly gathered at specific times of the year. Symbolic of Thailand's deep religious beliefs. Monks, wrapped in simple lengths of dyed cloth, are a daily sight in any part of the country – north, south, east or west. Then there is the sweet, juicy mango, and everywhere marigolds – the colour of the earth, a ritually proffered gift to the temple shrines.

A novice monk at Sukhotai, Central Plains

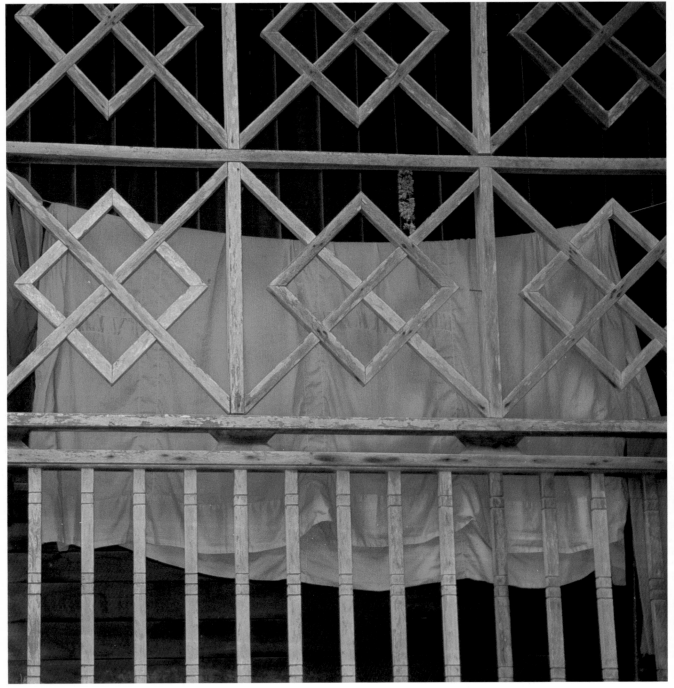

Above Saffron robes hanging out to dry on the wooden verandah of the monks' quarters

Opposite Two novice monks inside the wooden *viharn* (hall) of Wat Pra Srirantana Mahathat,
Phetchaburi, southeast Thailand

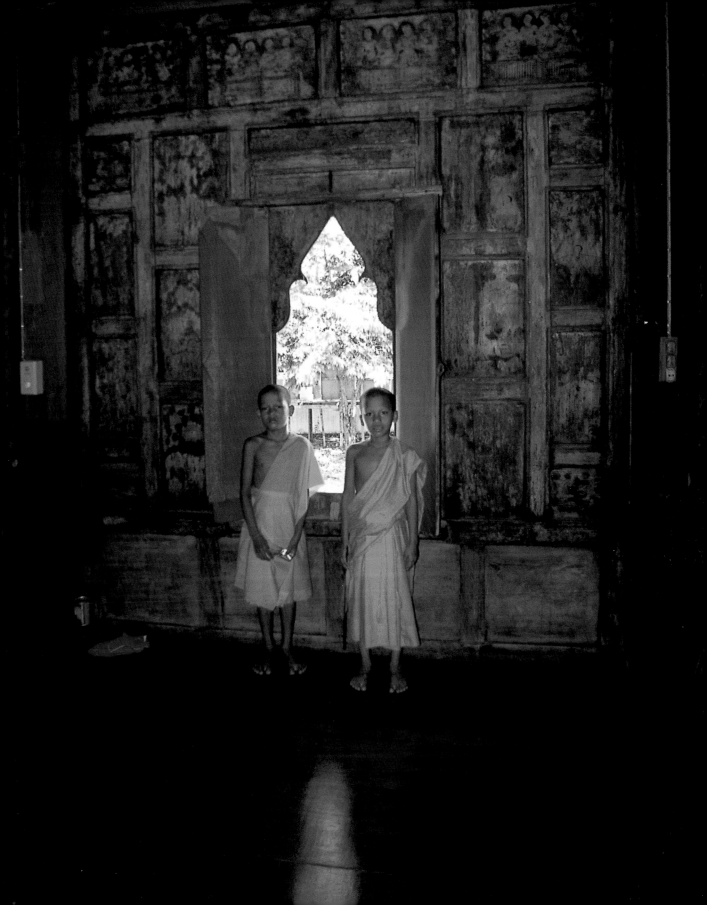

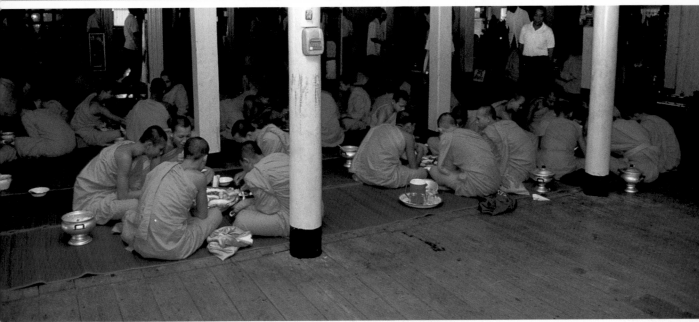

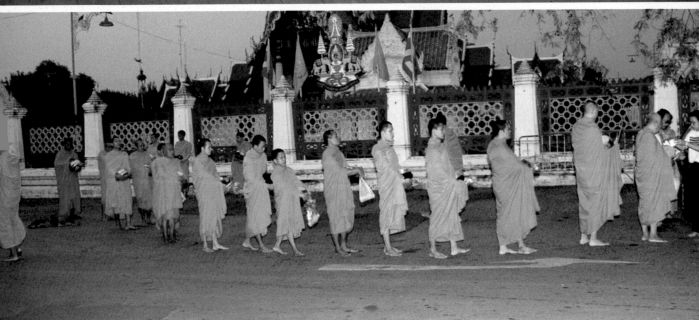

Top Initiation banquet of novice monks at Wat Phra That Doi Kong Mu, Mae Hong Son, northwest Thailand. Their families have prepared elaborate food which is first served to the older monks

Bottom The ceremony of Tak Bat Devo – by giving alms to the monks at dawn, great merit is earned

Opposite The Thai-Chinese temple guardian at Jui Tui Chinese temple in Phuket Old Town

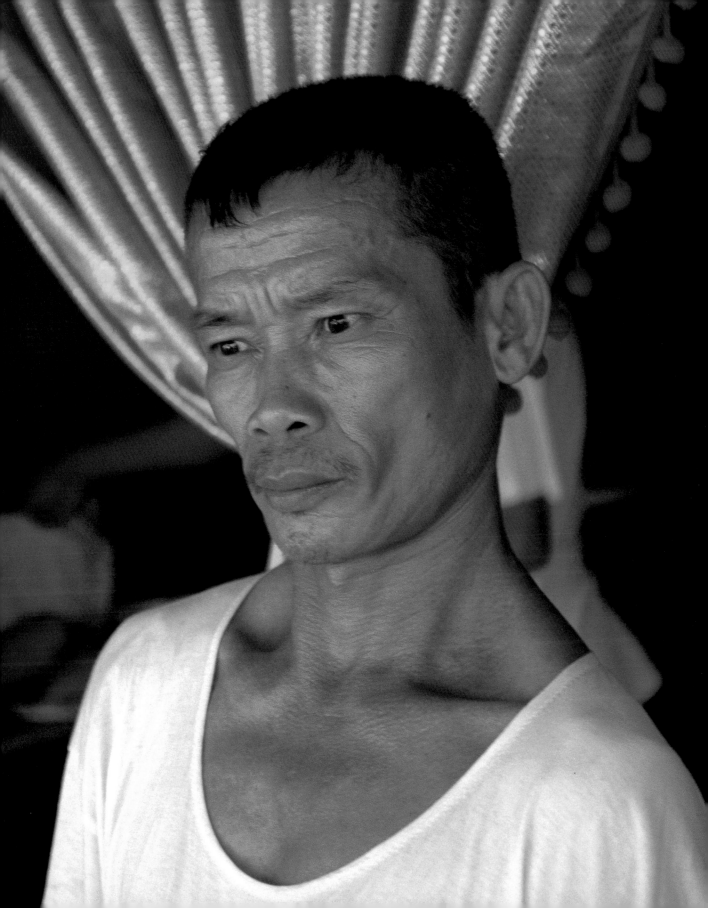

Above Temple offering of sweetmeats and prayer candles

Opposite Monks sweeping at Wat Suphannimit, Chumpon, southeast Thailand.
The *wat* (temple) is being restored

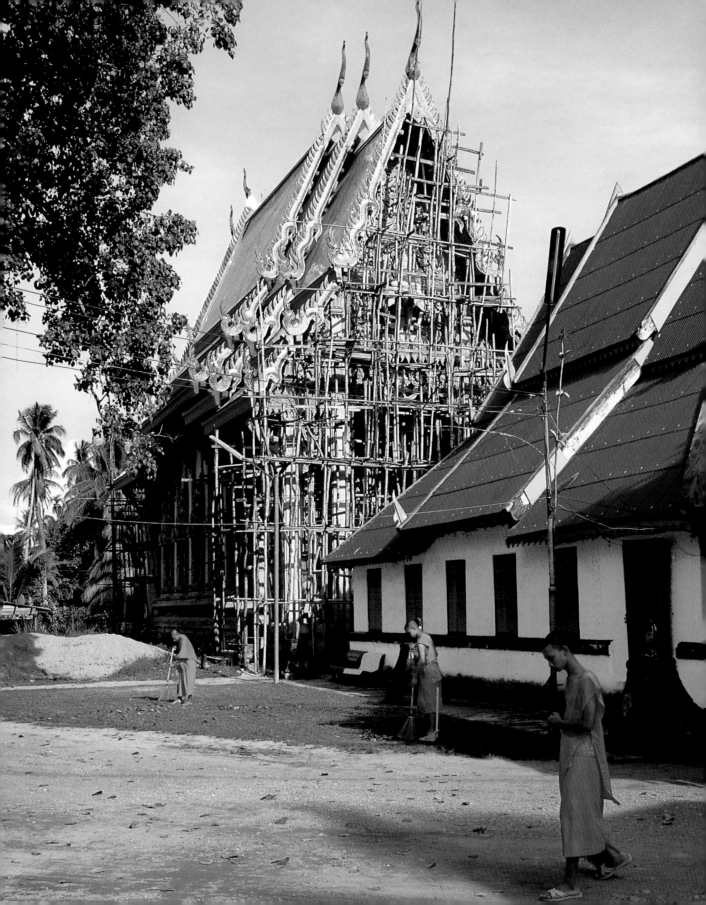

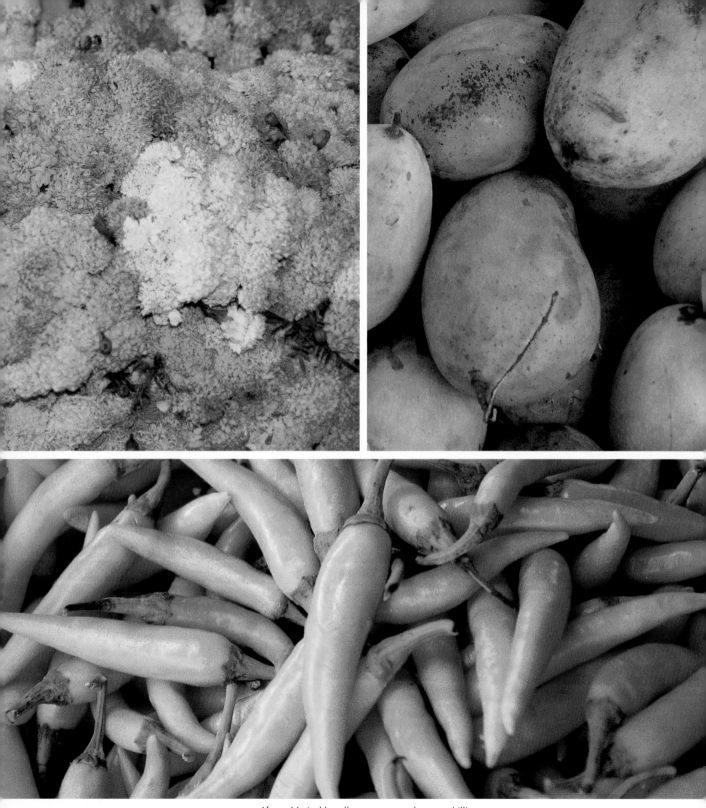

Above Marigolds, yellow mangoes and orange chillies

Opposite Detail of a meticulously crafted wax castle float for a popular festival,
Sakorn Nakorn, northeast Thailand

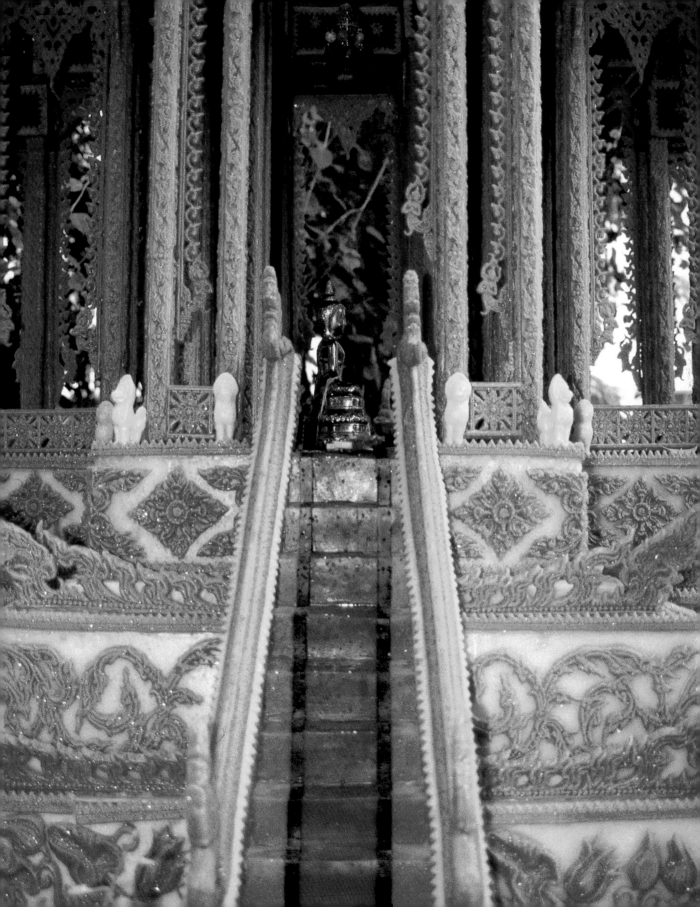

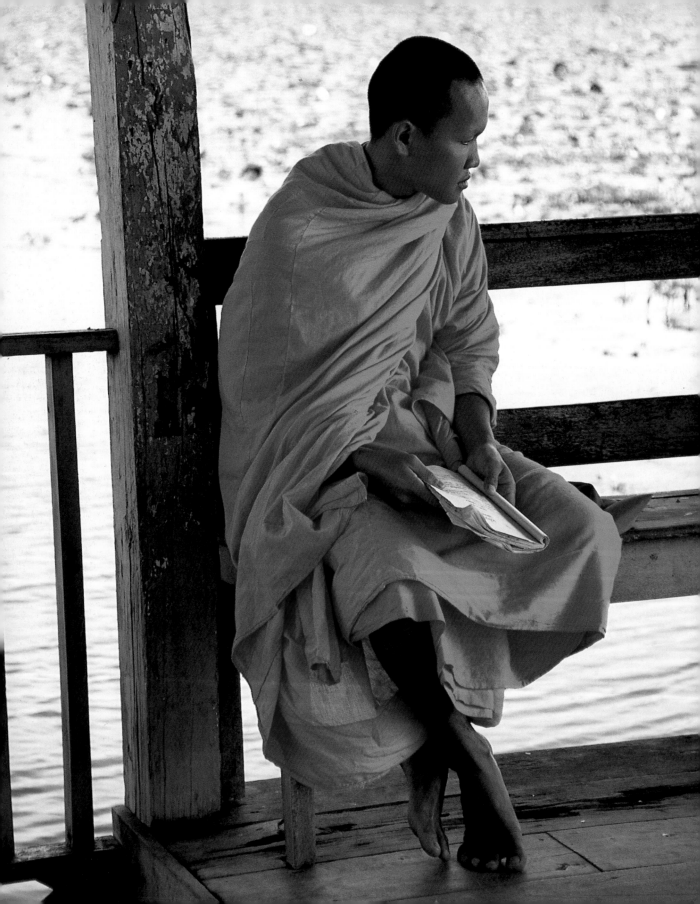

Opposite Saffron-robed monk meditating at a traditional Thai resting place overlooking a lily pond, Buri Ram district, central Thailand

Above Details of monks' cloths. Thais give cloth to their local *wat* during important festivals – unused fabric is passed on to poorer temples

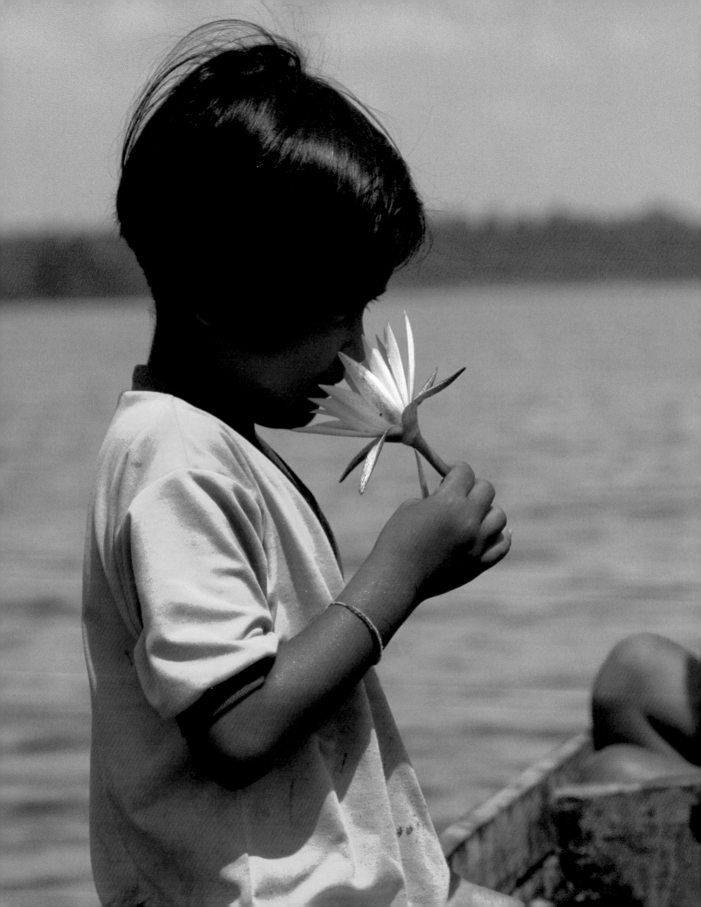

Opposite Plucking lotus blossom from Thale Luang inland lake, southern Thailand

Top Green mango sliced and preserved in brine

Bottom Thai silk made famous by Jim Thompson, the first to export it to the West after the Second World War

Following pages A new Buddha in 'Buddha Alley', Bangkok, covered in saffron cloth to keep it dust-free

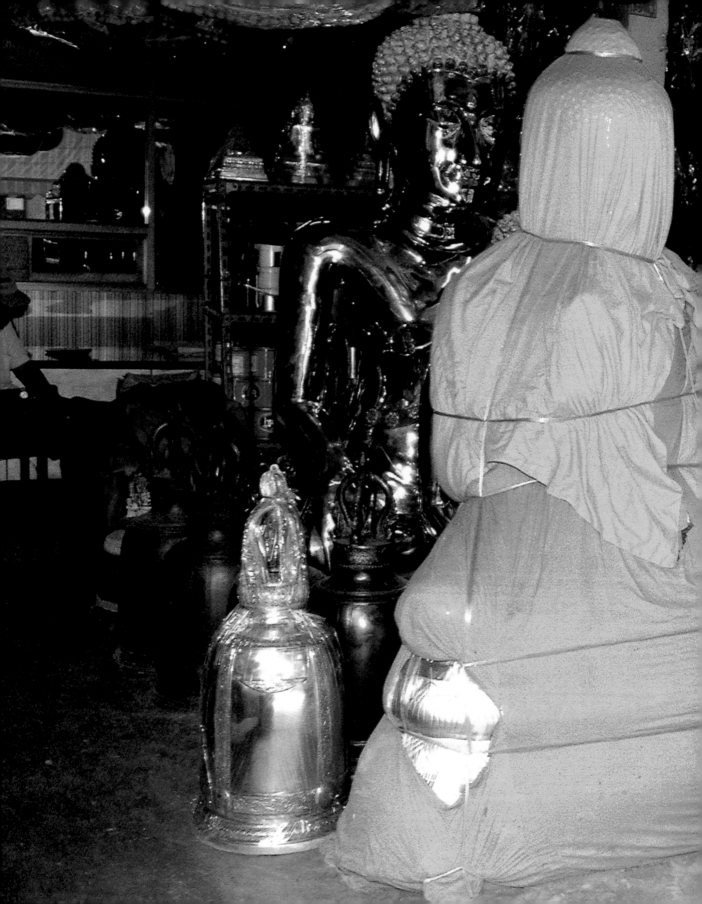

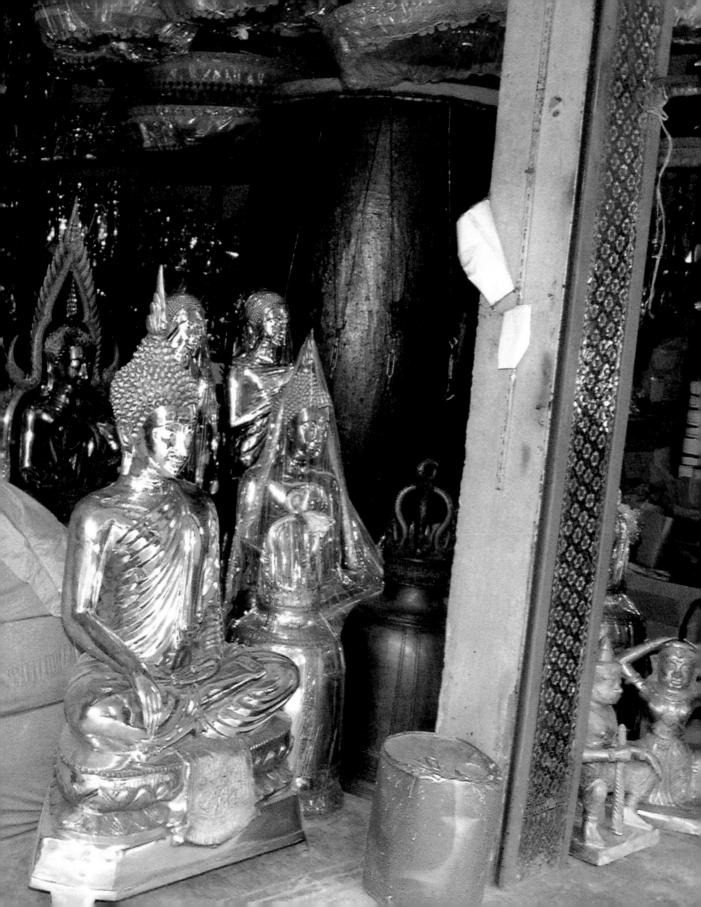

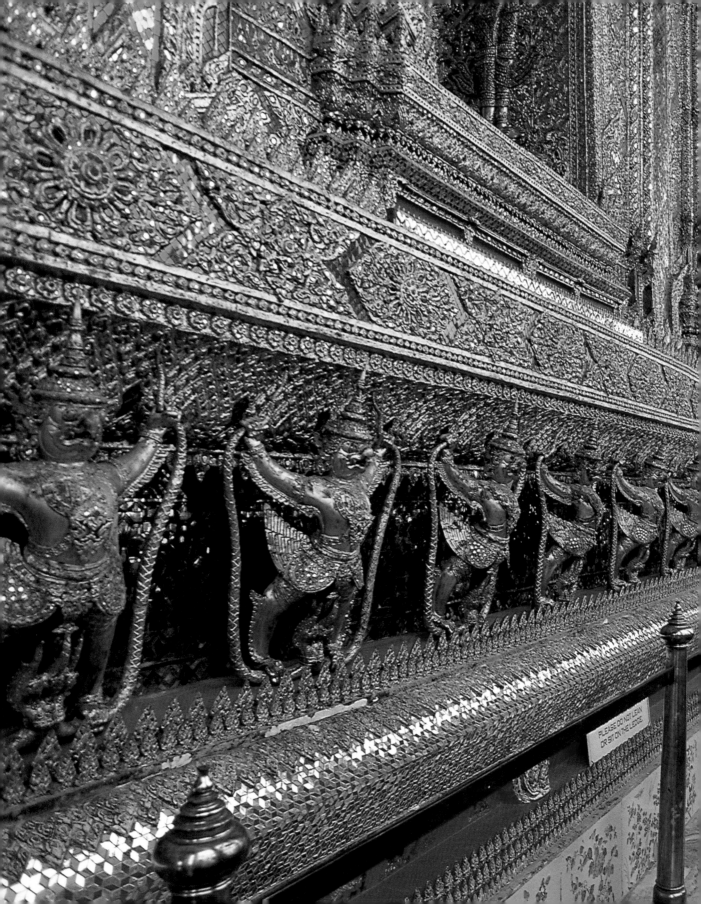

PLEASE DO NOT LEAN
OR SIT ON THE LEDGE

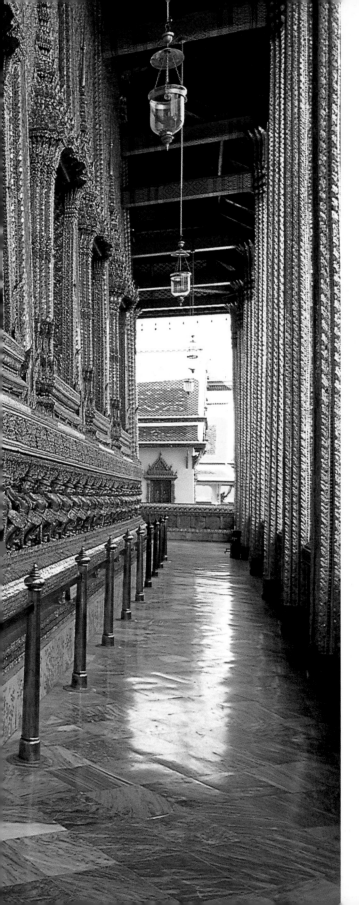

2.

Gold

Shimmering, refracting and reflecting off a myriad of roofs – it is impossible to escape the Thais' love of gold. From the Grand Palace in Bangkok to the smallest shrine in a faraway village, it is everywhere. Gold plate, solid gold, painted gold, gold leaf, gold thread. Golden Buddhas, gilded *garudas* (temple guardians) – corridors of gold to amaze and astonish. Golden sunsets. A gilded life.

Grand Palace, Bangkok. This building houses the giant Reclining Buddha

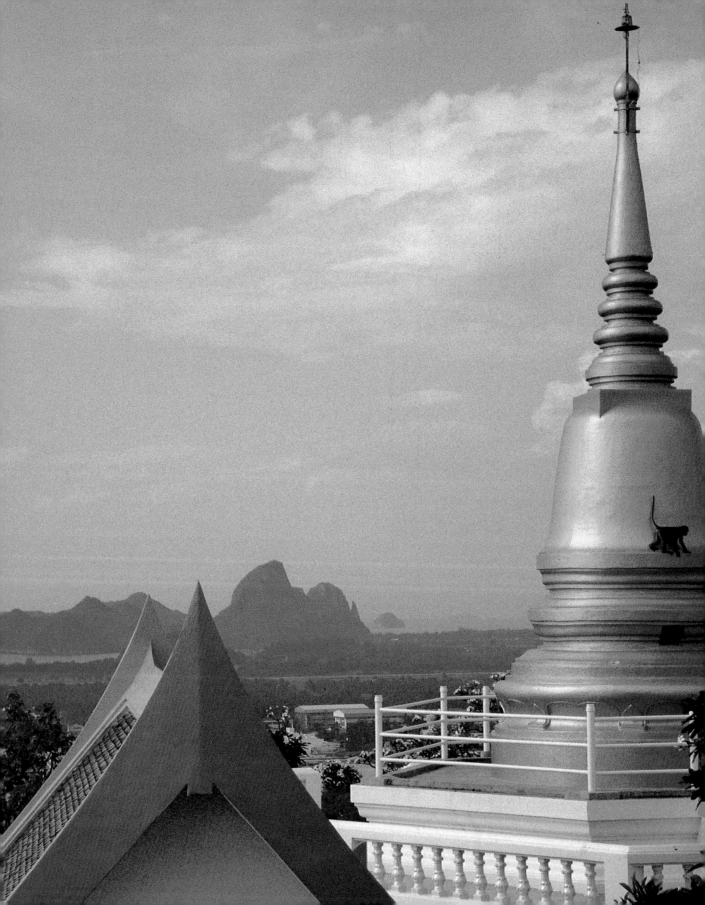

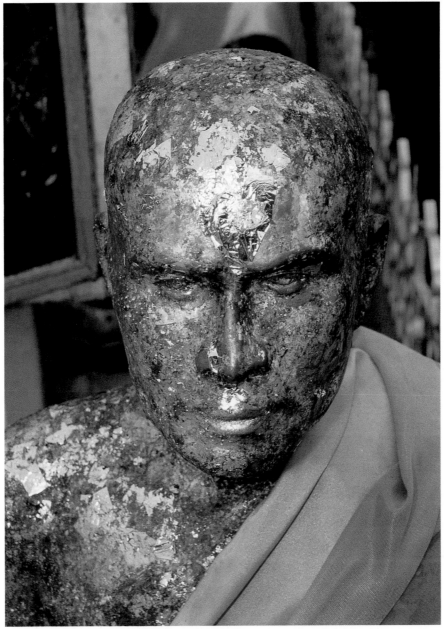

Opposite The gleaming roof and *chedi* (tower) of the *wat* at Prachuap Khiri Khan
overlooking the Gulf of Thailand

Above A Seated Buddha plastered with gold-leaf prayer offerings

Following pages The Grand Palace, Bangkok

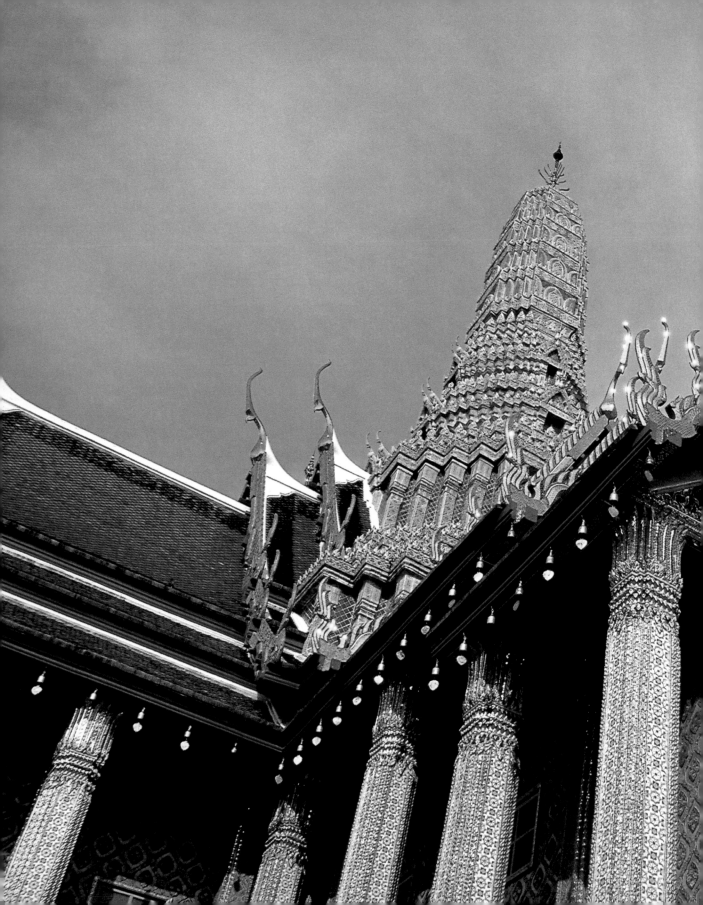

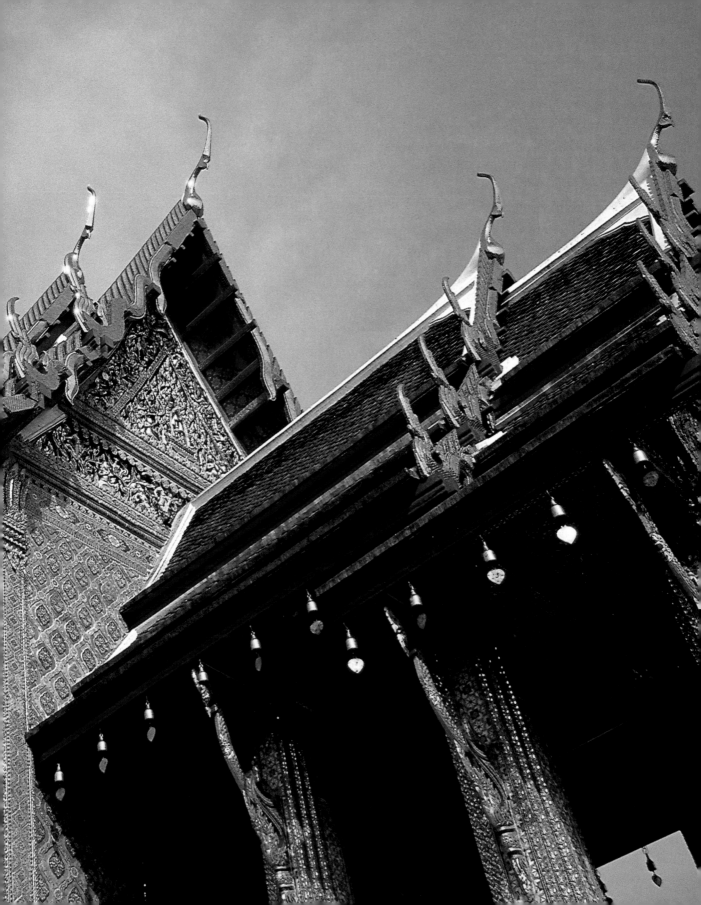

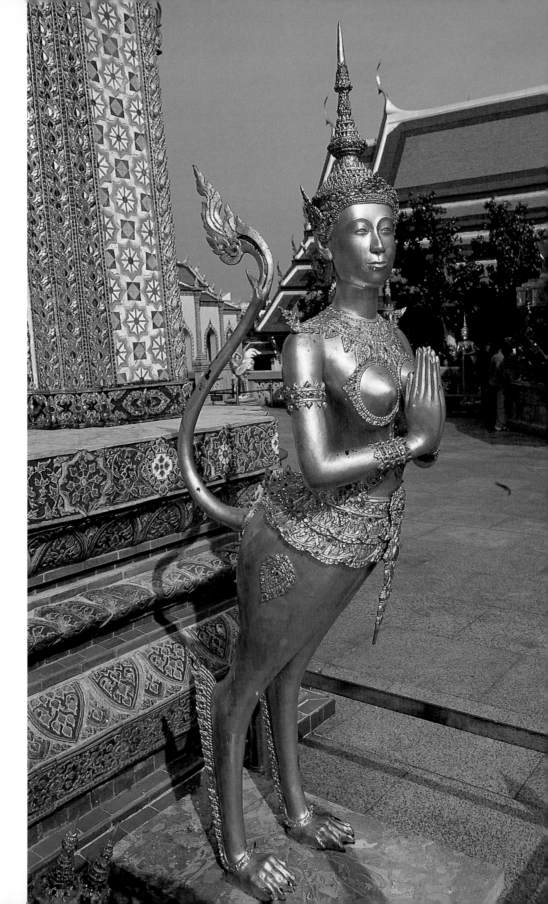

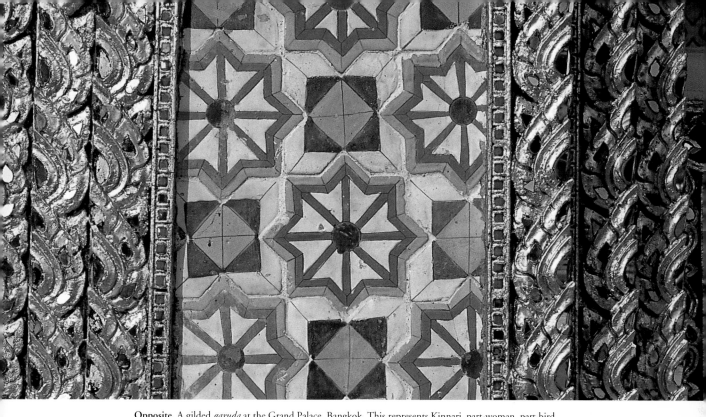

Opposite A gilded *garuda* at the Grand Palace, Bangkok. This represents Kinnari, part-woman, part-bird

Above and below Inlay detail at the Grand Palace, Bangkok

Following pages A row of Seated Buddhas at Wat Mahathat, Phitsanulok, Central Plains

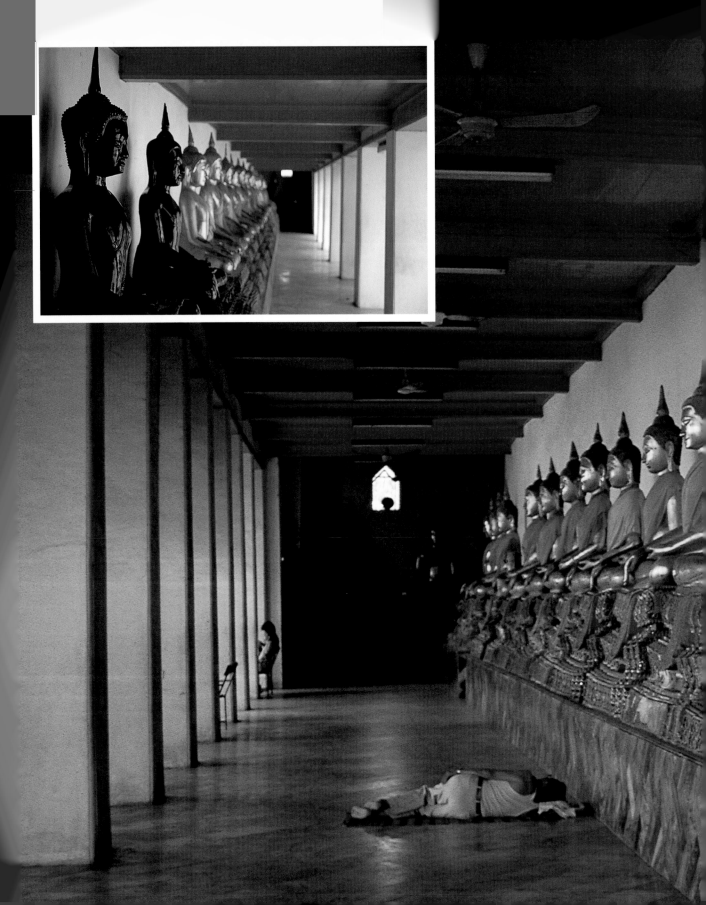

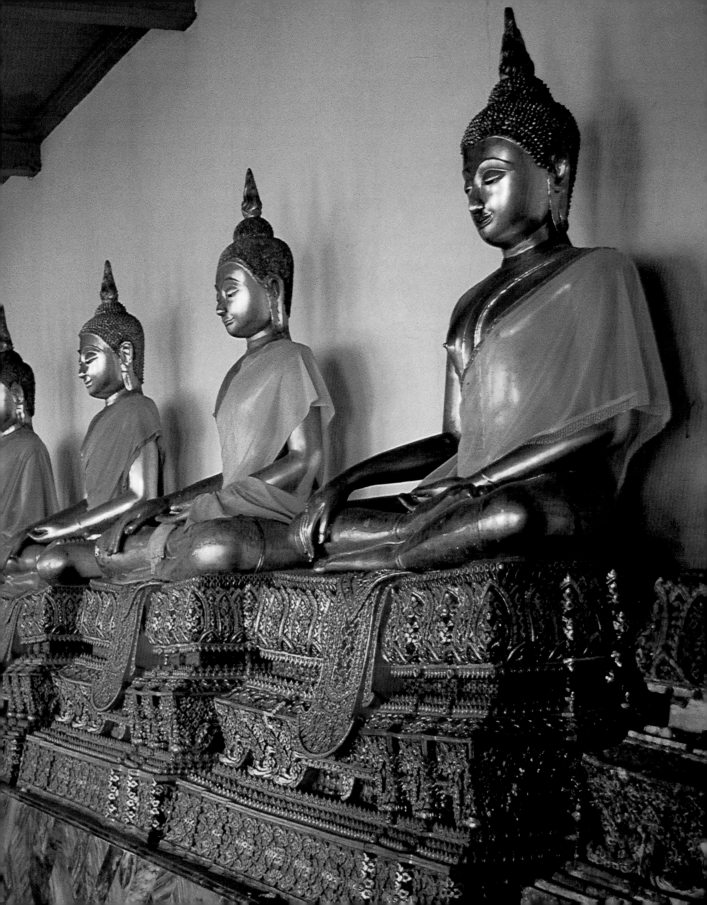

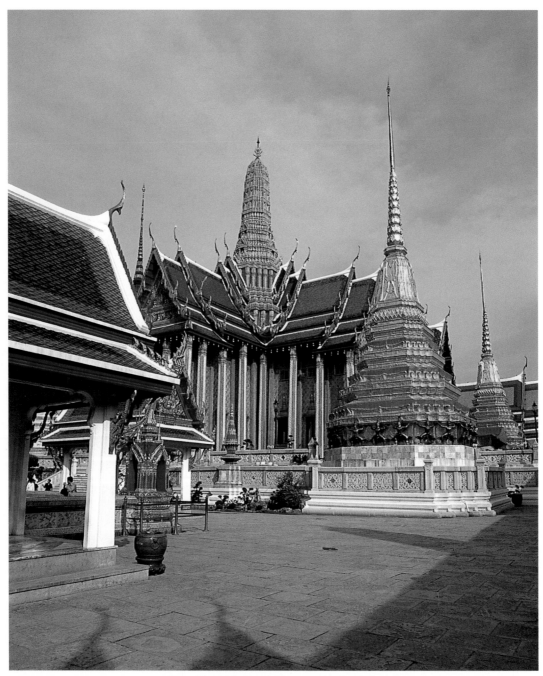

Above View of the Grand Palace complex, Bangkok

Opposite Detail of fine stucco work at Wat Phra Kaew, Bangkok, with its *chedi* in the distance

Following pages A golden sunset at Ko Samui, southeast Thailand

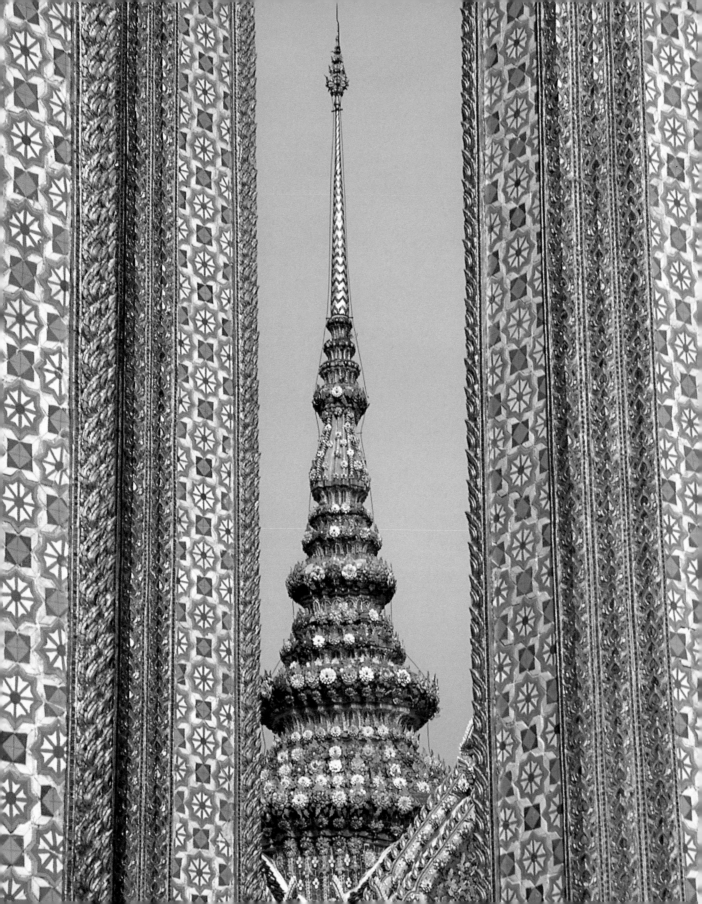

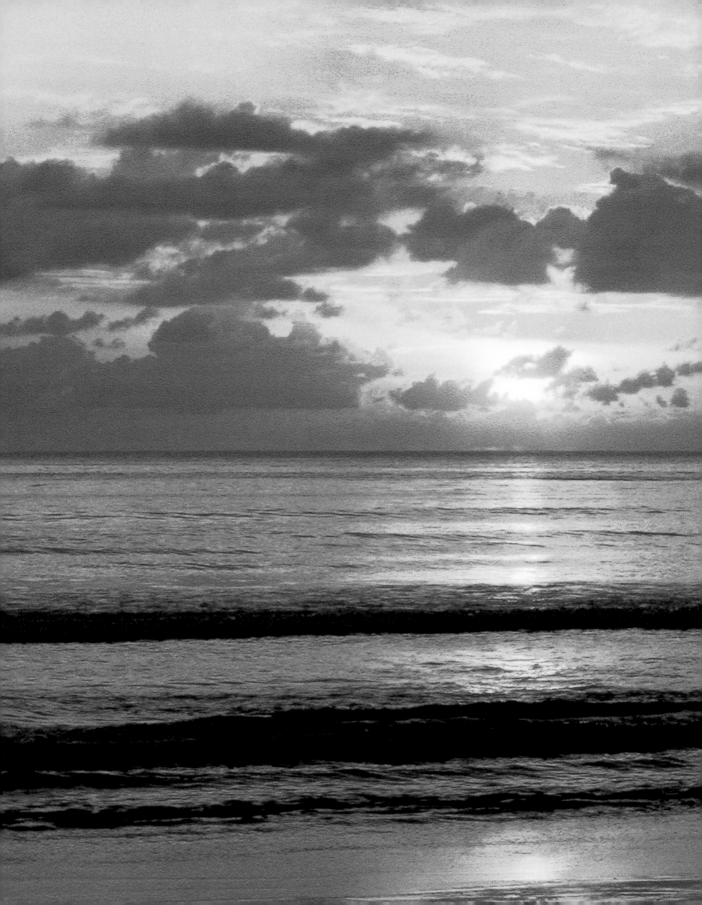

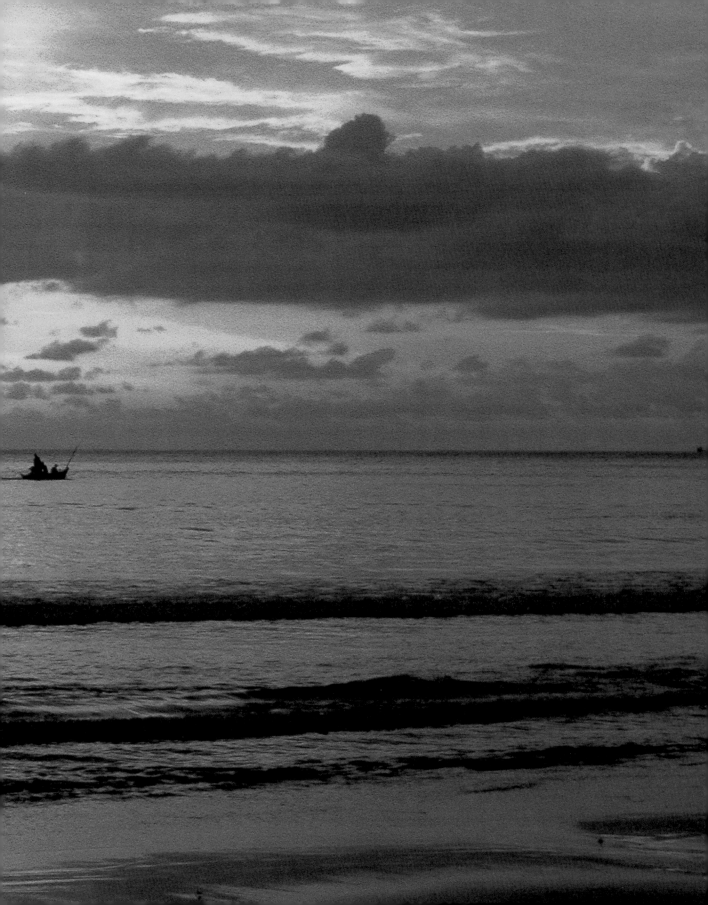

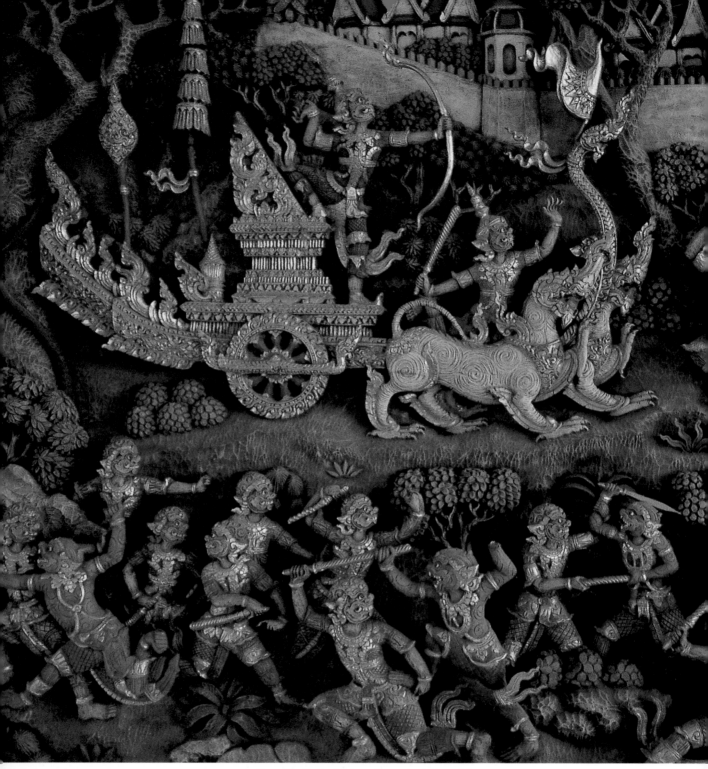

Above Detail of a gilded wooden carving, Phitsanulok

Opposite Details of the mural in Wat Phra Kaew, illustrating the Thai version of the Ramayana
'Ramakien' – the life of the Lord Buddha before his enlightenment

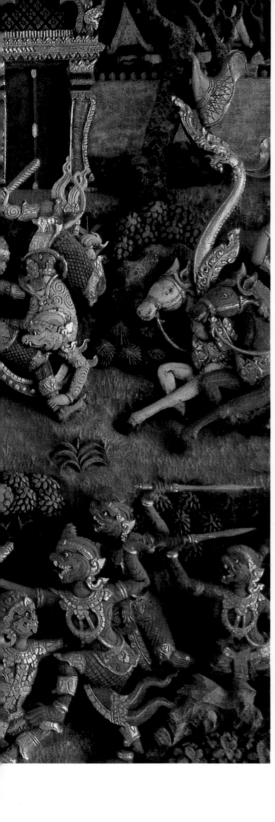

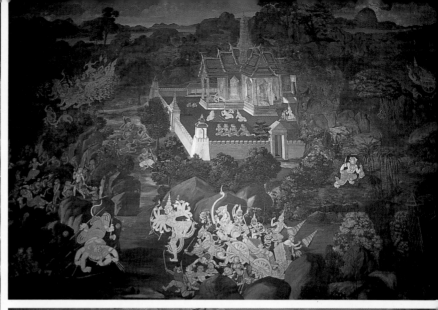

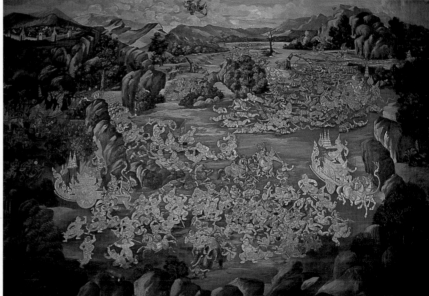

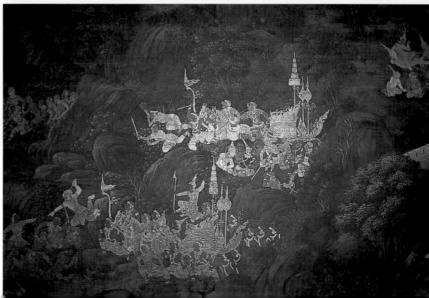

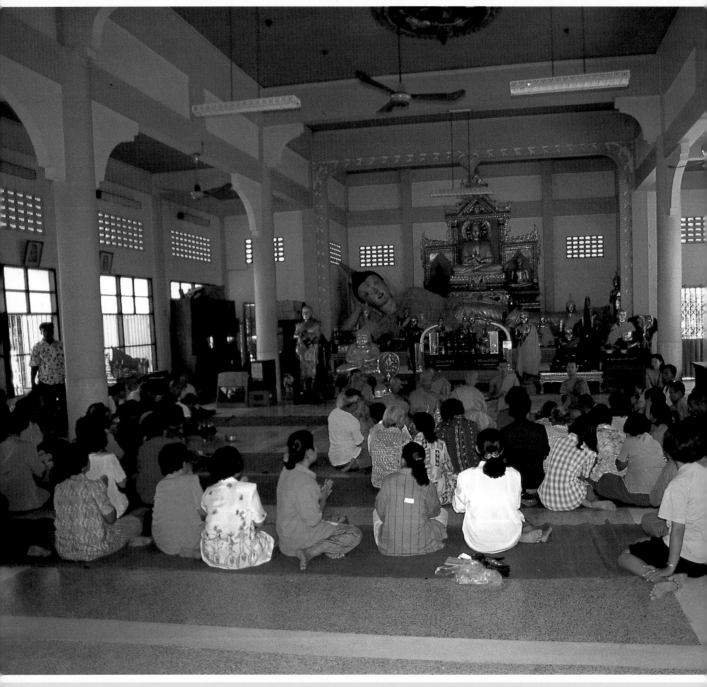

Above Wat Chian Hai, Satun Province, southern Thailand. The families of novice monks attend their sons' ordination

Opposite A tribute to King Bhumibol Adulyadej at an altar in the Grand Palace, Bangkok

Following pages Recently finished, highly polished Meditating Buddhas awaiting purchase, Bangkok

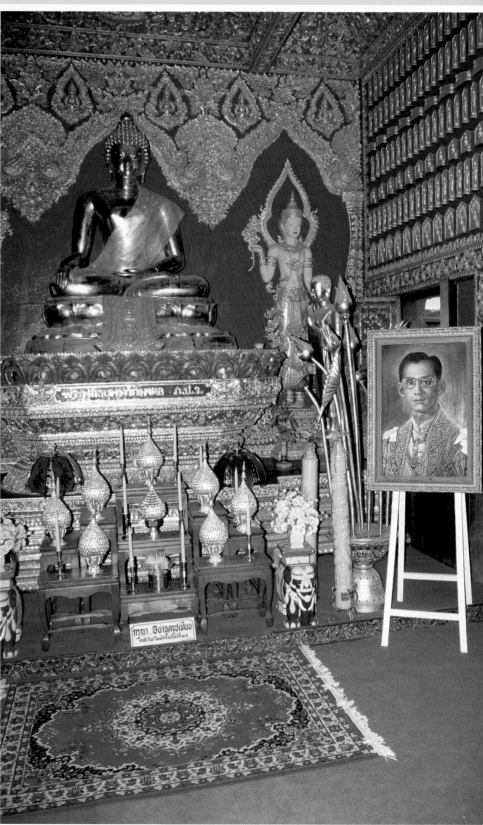

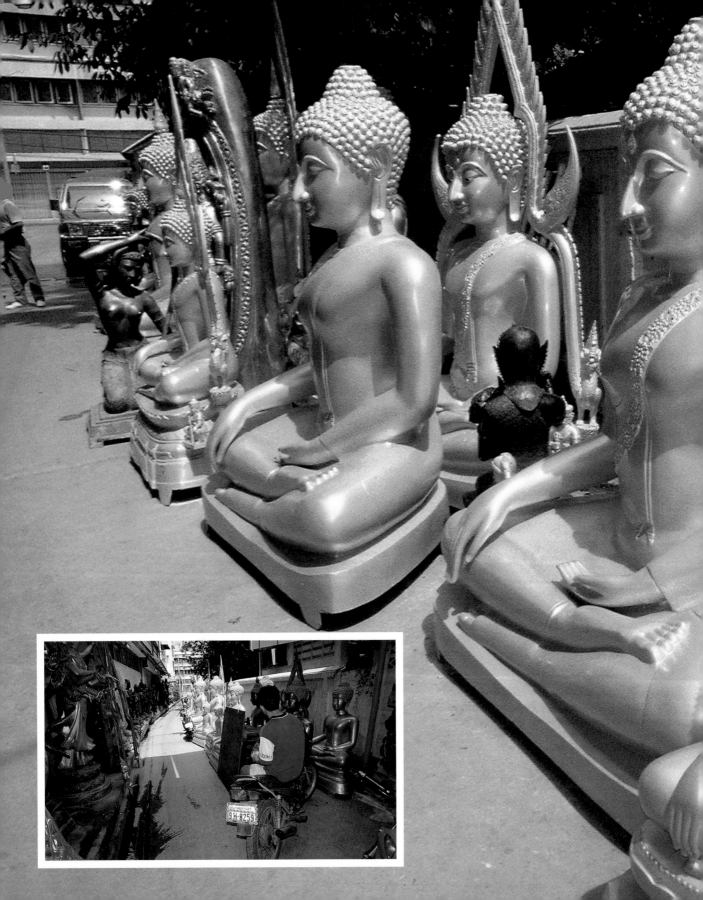

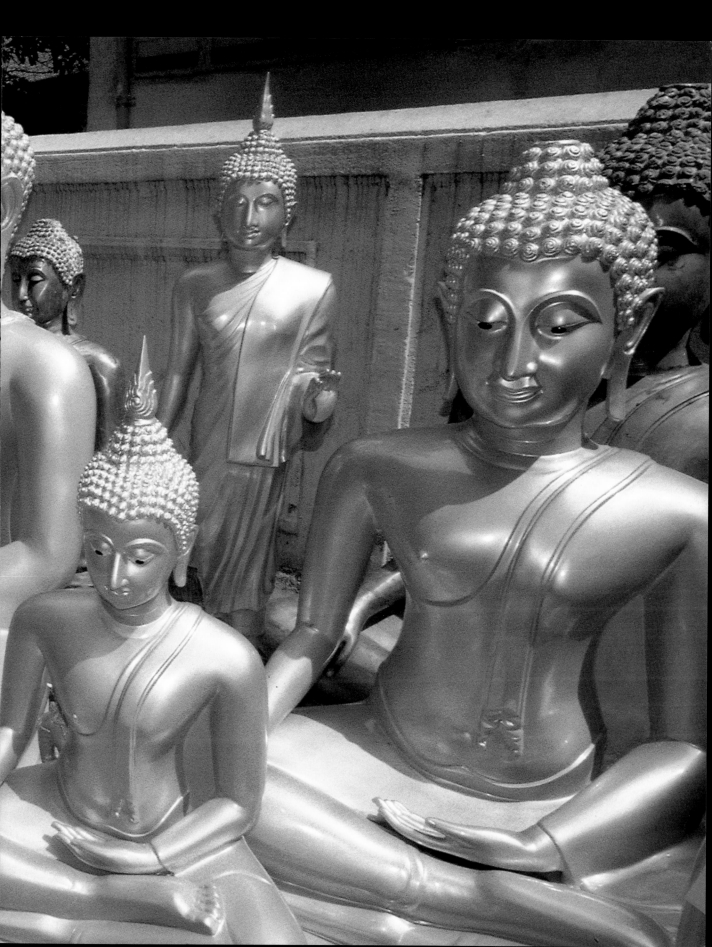

3.

Black

Black is not always associated with menace and evil in Thailand. Secret and silent, its shadows are full of life and joy. Night is the time to indulge in the national passion for fireworks. At the November Illuminated Boat Festival, vast constructions are launched, teetering dangerously on the water, hot air balloons carry candles into the black sky like giant fireflies. Broad-hatted women sell their wares in the shady corners of the *klongs* (canals). Life continues at a comparatively slow pace away from the rigours of the fierce sunlight.

The mysterious, cool cave sanctuary at Khao Luang

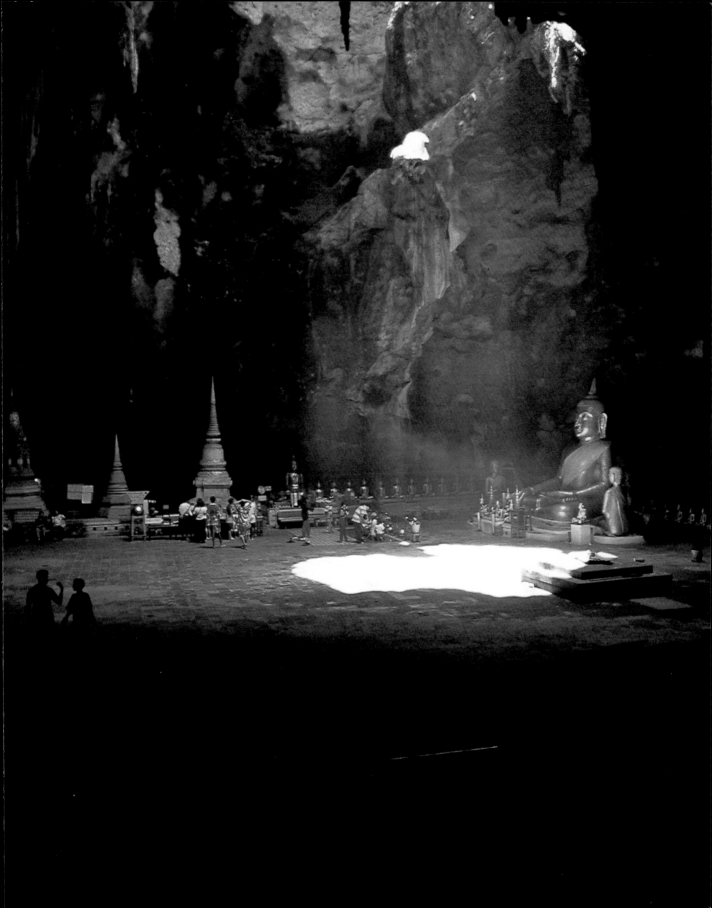

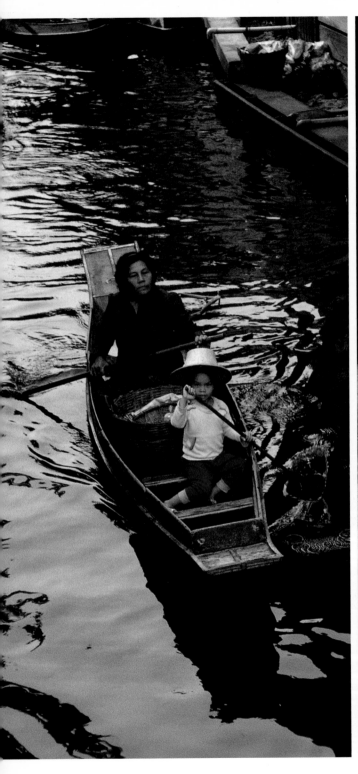

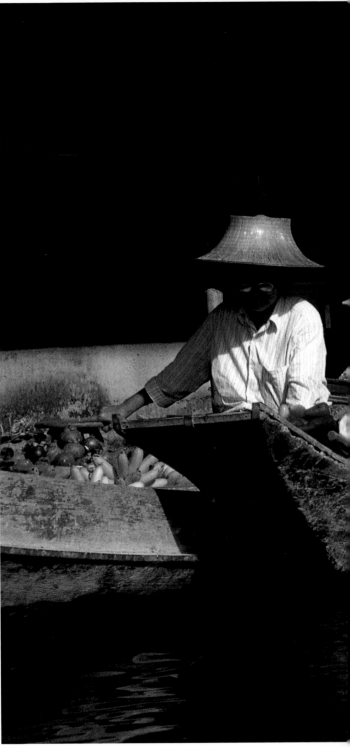

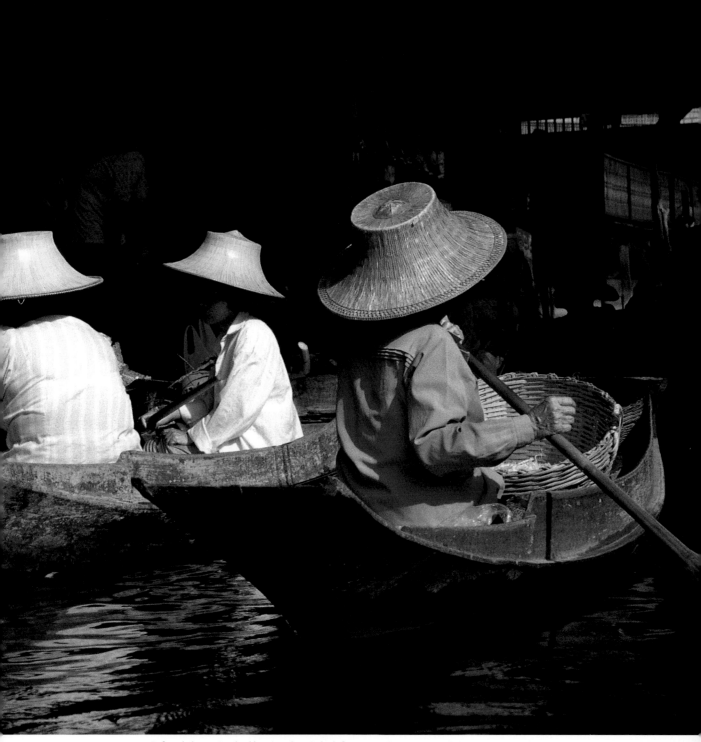

Left and above On the *klong* (canal) at Saduak floating market. Women sell their wares on their traditional sampans, manoeuvring expertly in the narrow waterways

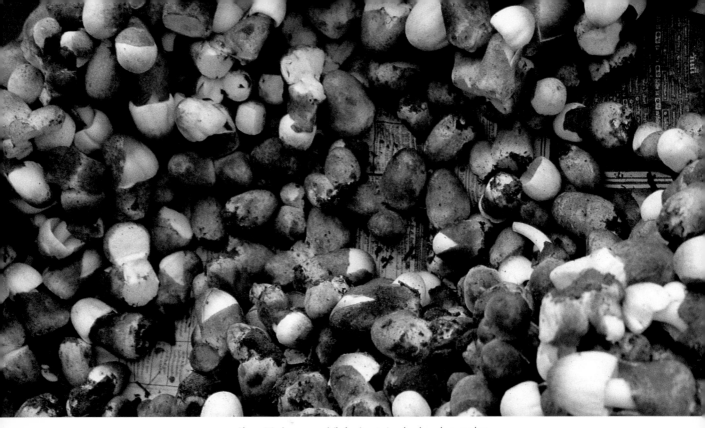

Above Mushrooms and (**below**) nuts in a local produce market

Opposite One of Thailand's oldest and most beautiful sites, Wat Phra Mahathat, in the town of
Nakorn Si Thammarat, Surat Thani Province, southern Thailand

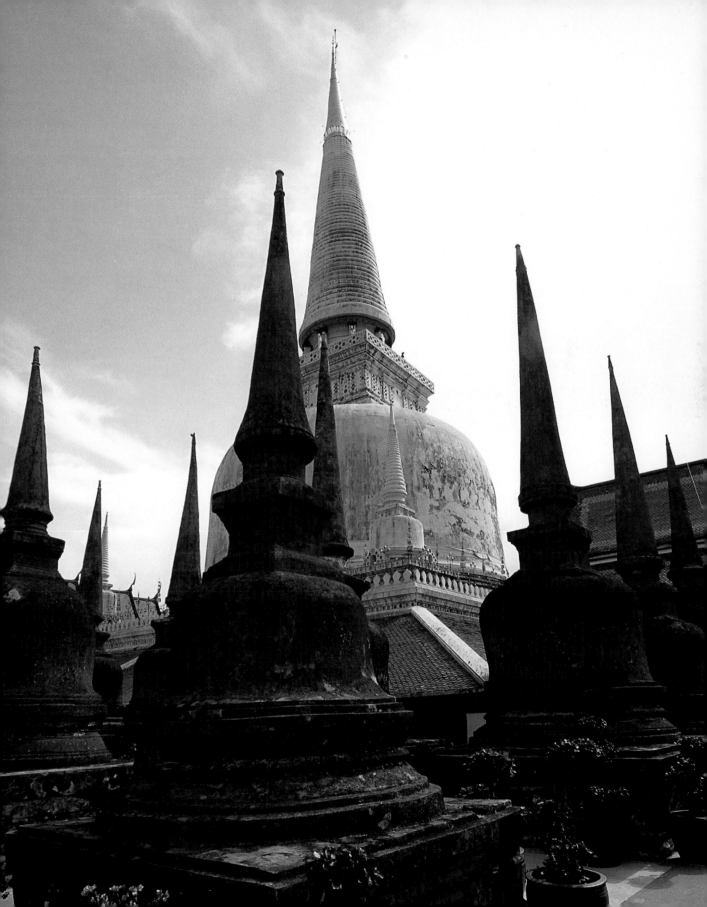

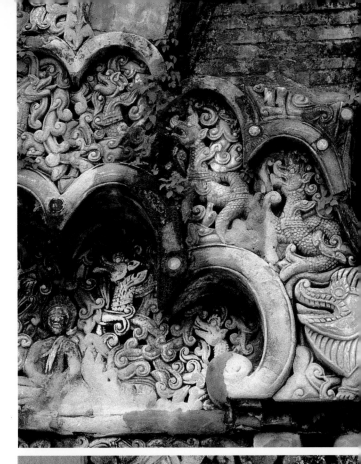

Above and below Details of stone carvings at a sixteenth-century *chedi* on the Mekong River, Isan Province

Opposite Family memorial or spirit house on a temple wall, Phuket Province

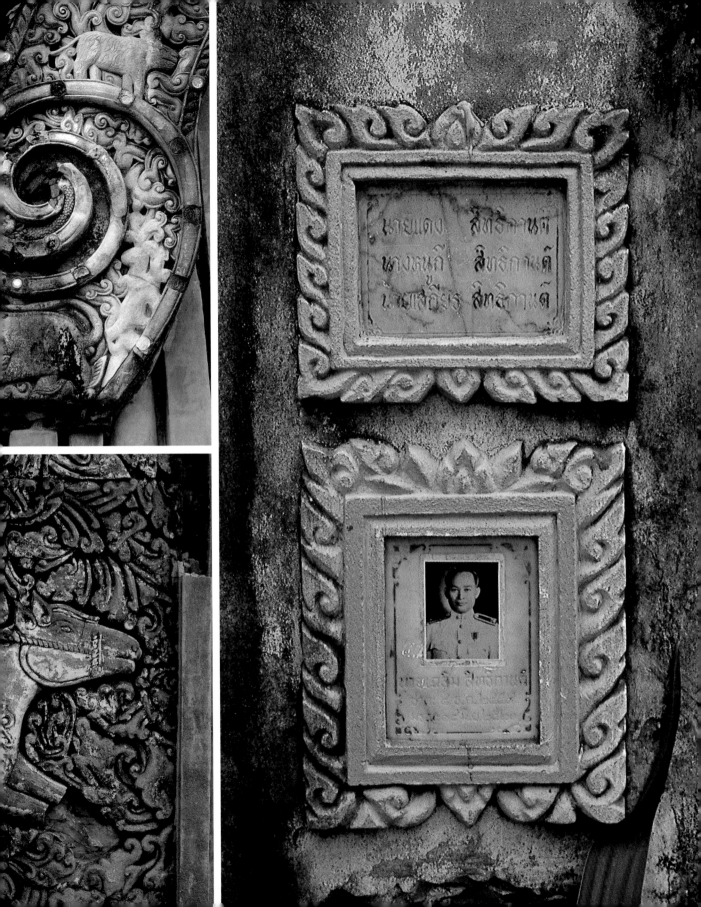

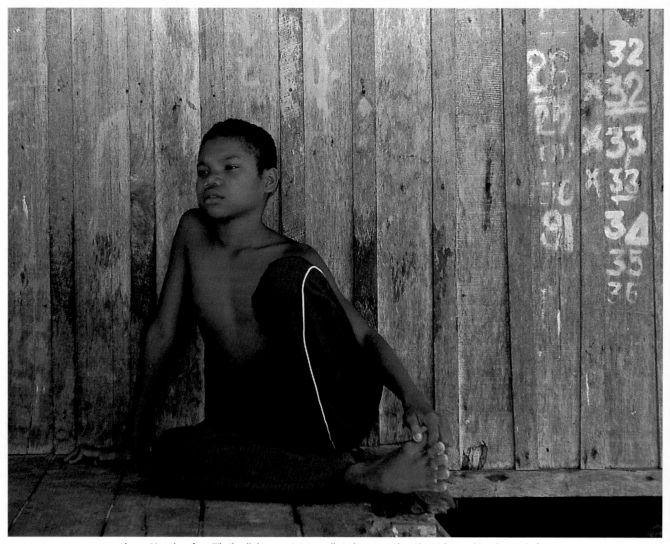

Above *Ngaw* boy from Thailand's last remaining totally indigenous tribe. Also nicknamed 'rambuttans' after the fruit because of their spiky hair, they live on the border with Malaysia

Opposite Woman in Songkla Province, a predominantly Muslim area close to the border with Malaysia

Following pages Cyclist on a bridge over the River Nan, northern Thailand
(inset) Rainclouds threatening in Phuket

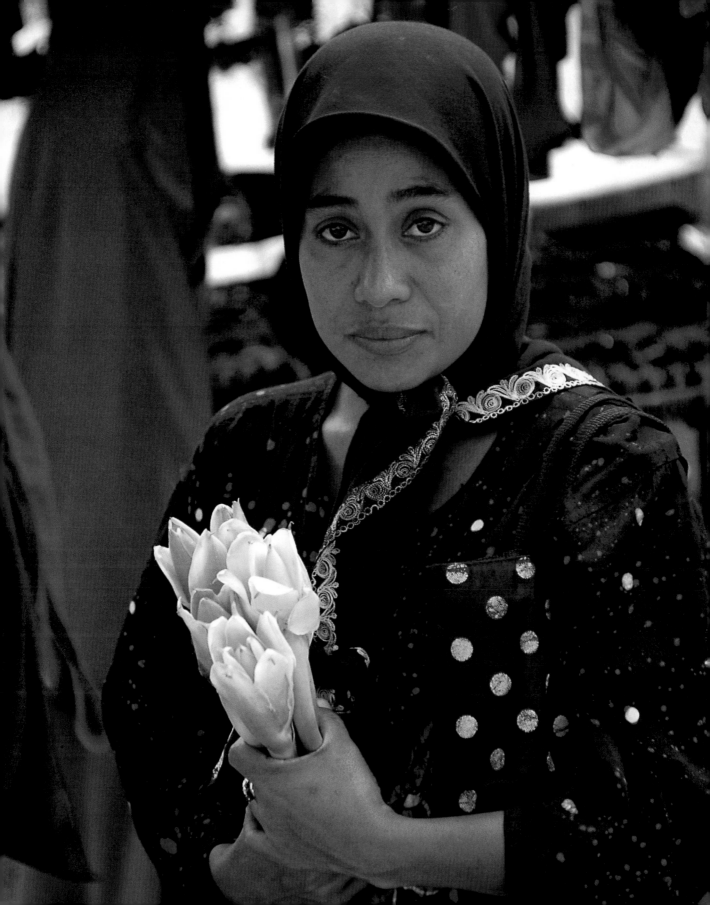

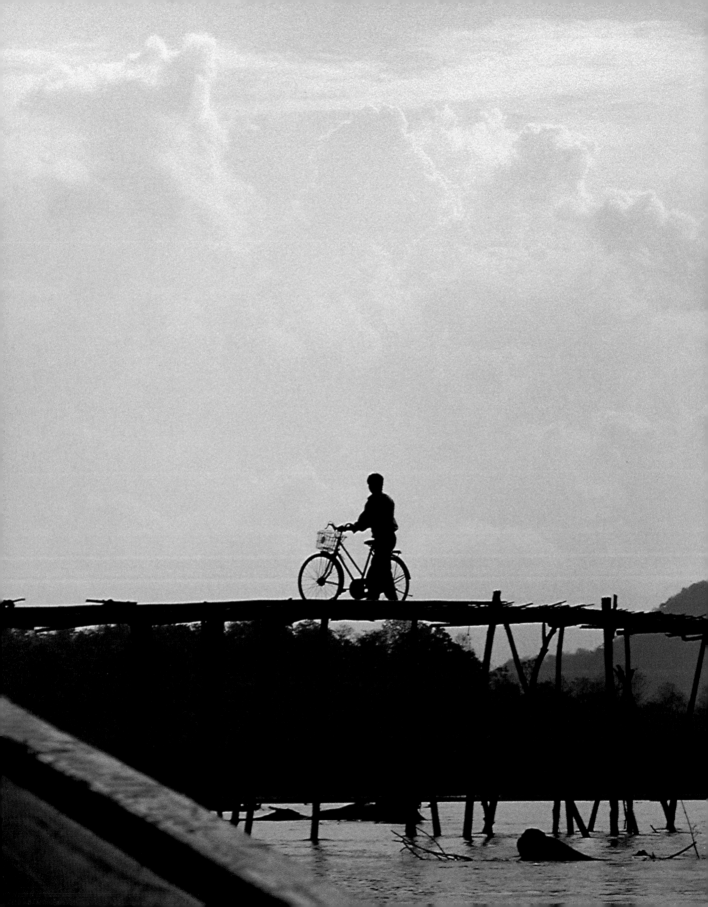

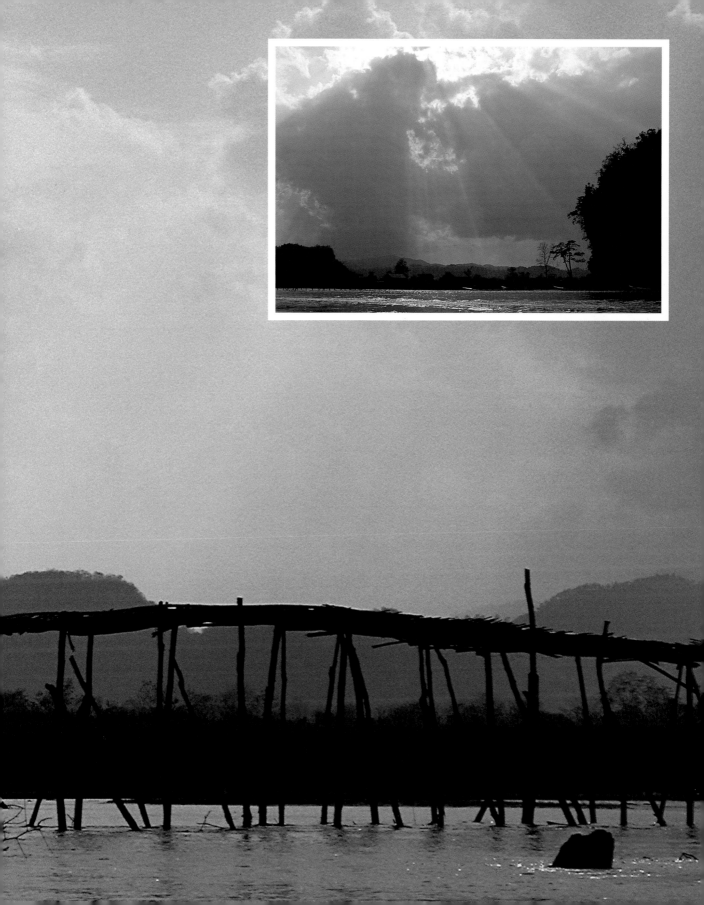

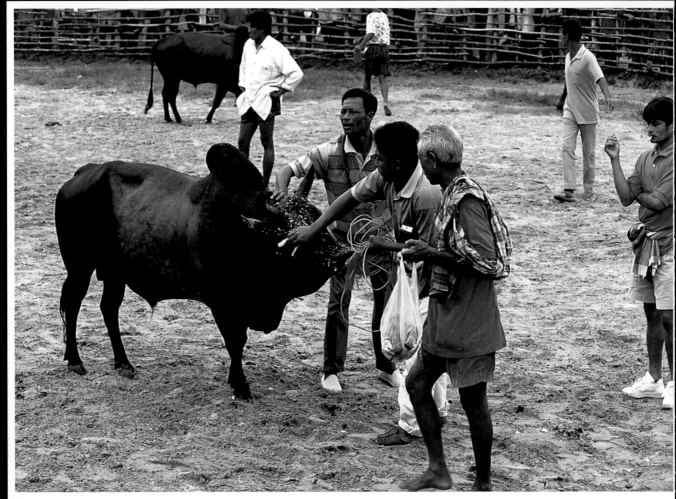

Before the bullfight, Trang, southwest Thailand: the bullock's face is smeared with banana

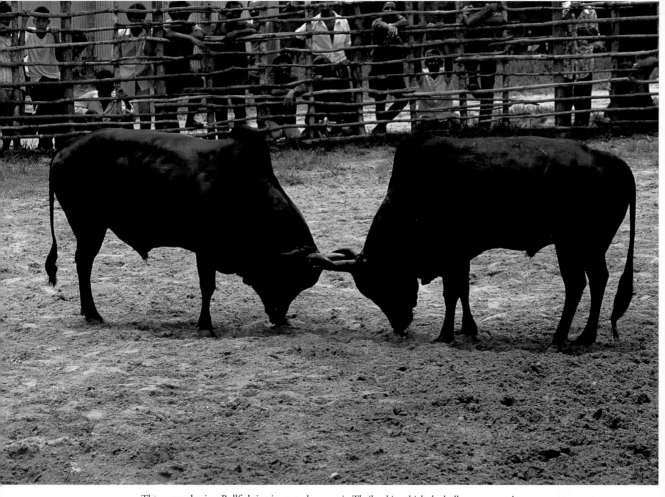

The contest begins. Bullfighting is a popular sport in Thailand in which the bulls come to no harm

Above Lanterns at the Loy Kratong Festival of light at Sukhotai, Central Plains

Below Illuminated tribute to King Bhumibol Adulyadej on the Mekong River, northeast Thailand

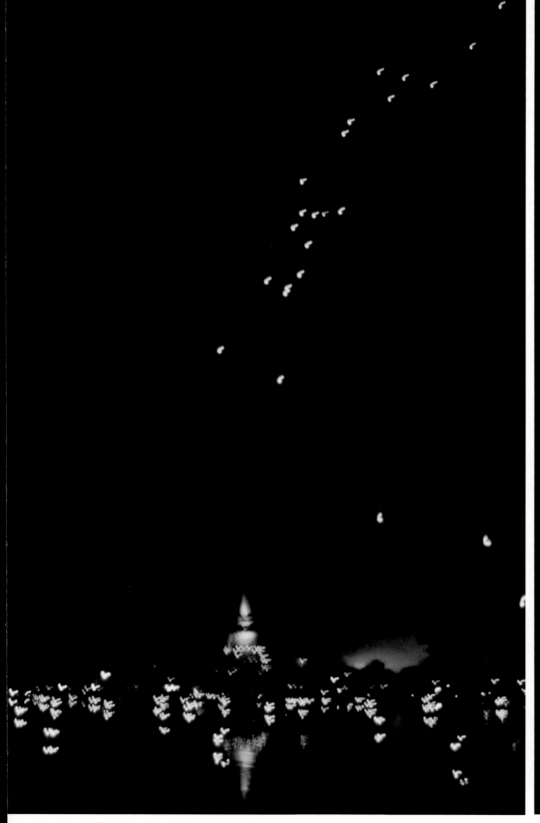

Above Paper hot air balloons, powered by candles, floating in the night sky at Sukhotai, Loy Kratong Festival, Central Plains

Following pages Long-tail boats await passengers on 'James Bond' island near Phuket

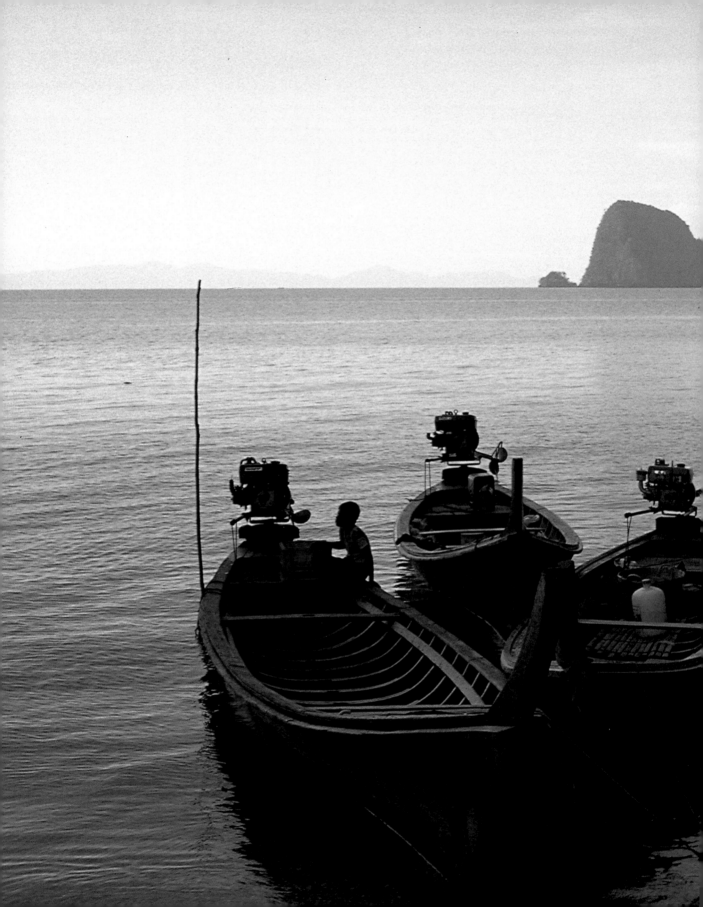

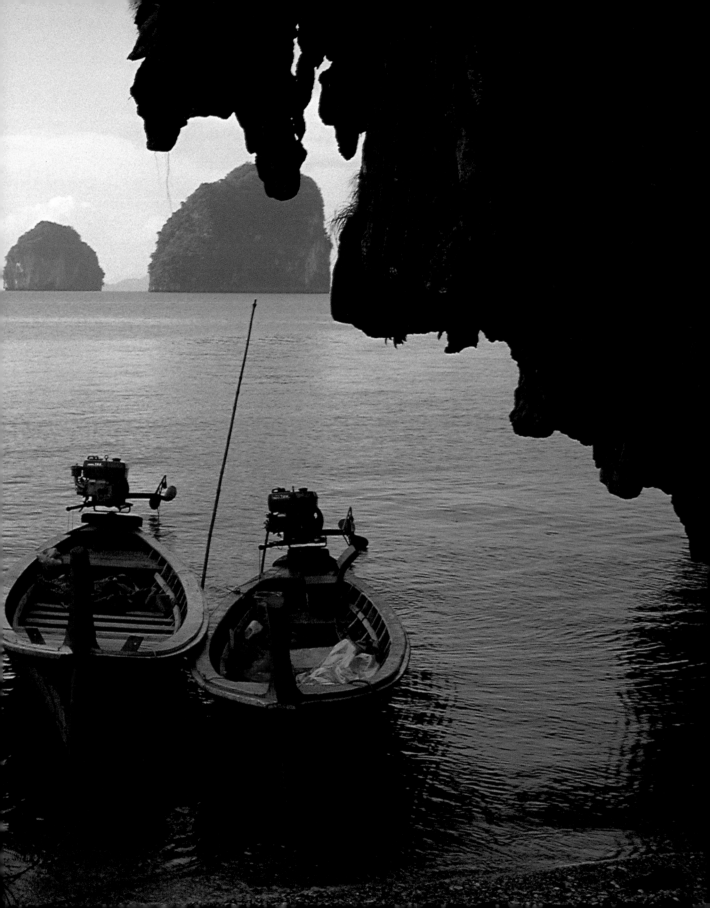

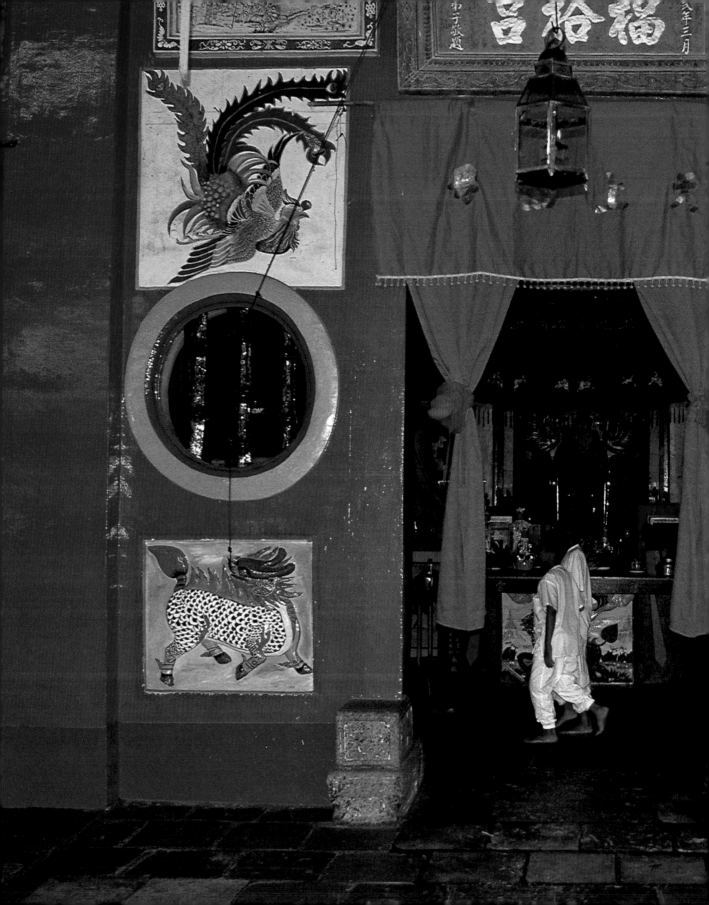

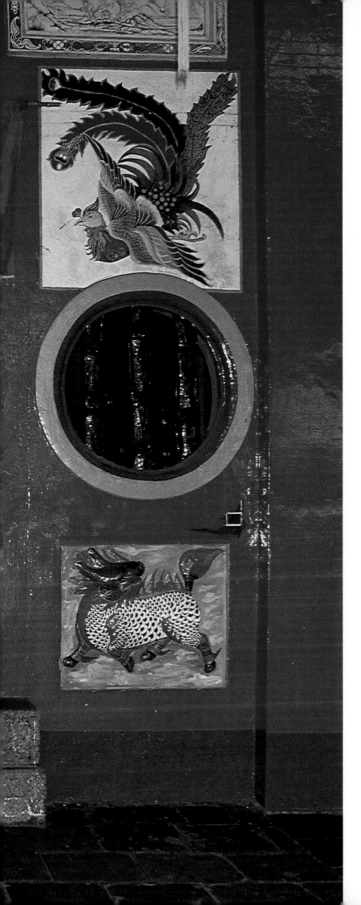

4.
Red

CRIMSON AND all its variations bring another aspect to the Thais' devotions. Here we have passion and heat – the 'Vegetarian' Festivals which are celebrated in the southern states in the name of faith are quite extraordinary. Donning red robes, men and women perform strange religious rites. Fruit and flowers are imbued with a vibrancy and brightness which only comes of a warm climate. The sun rises as a vermilion ball at day's first light, like the shining gloves of the young Thai kick-boxer, poised for confrontation. Life and passion, heat and fire.

Entrance to Phuket's principal Chinese *wat*, Jui Tui, adorned for the Vegetarian Festival. Thai-Chinese wear white to symbolize purity

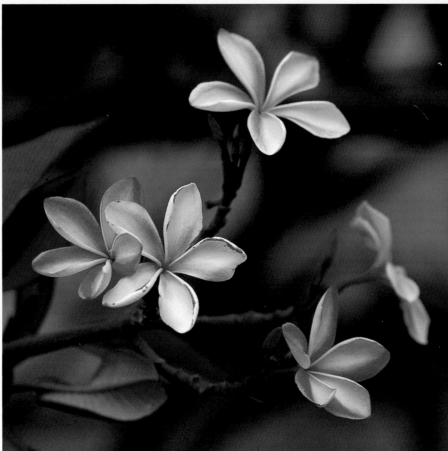

Above (left) Roses, grown in vast nurseries outside Bangkok to satisfy the Thais' love of flowers
(right) Frangipani

Opposite Viewed from above, the waterborne butcher's sampan drifts by

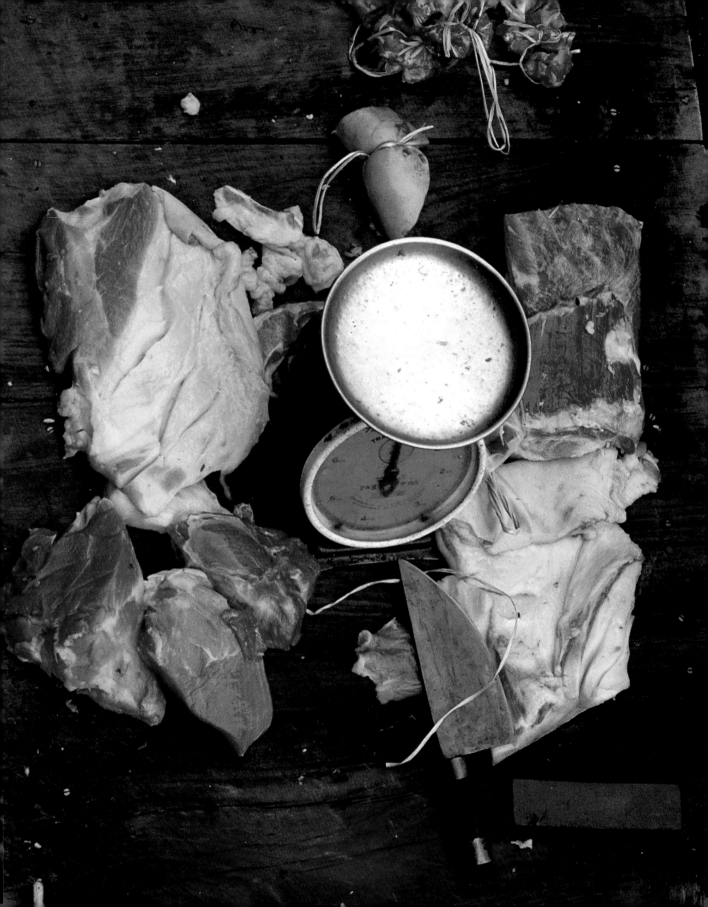

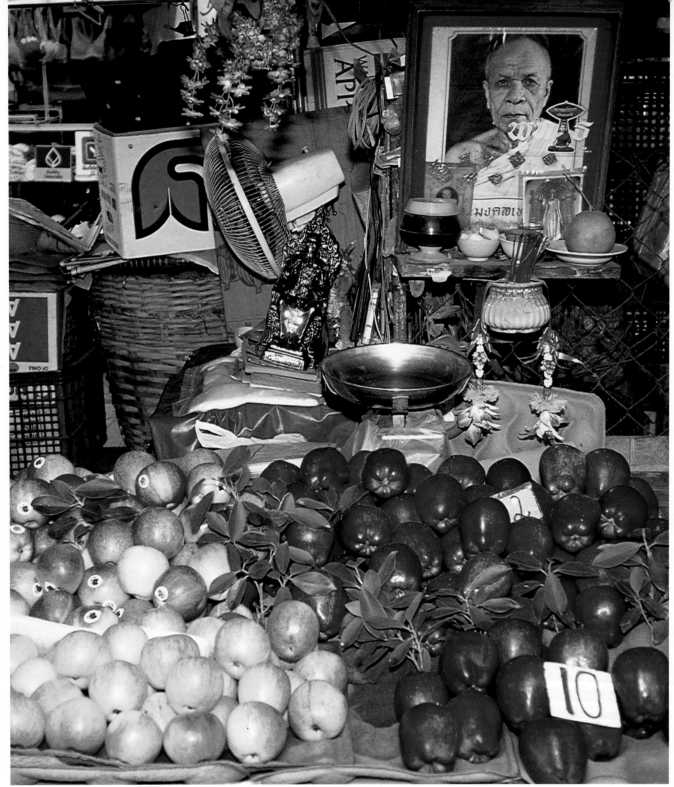

Above Apples in a Bangkok market

Opposite Detail of a Muslim fishing boat at Panare, southern Thailand. The boats are lovingly painted with idyllic images

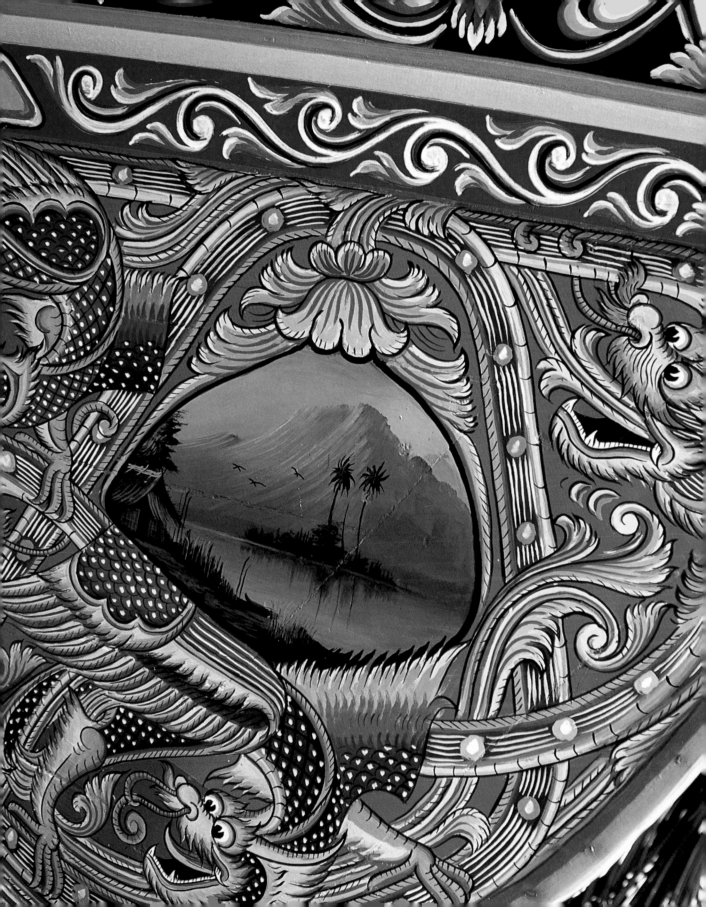

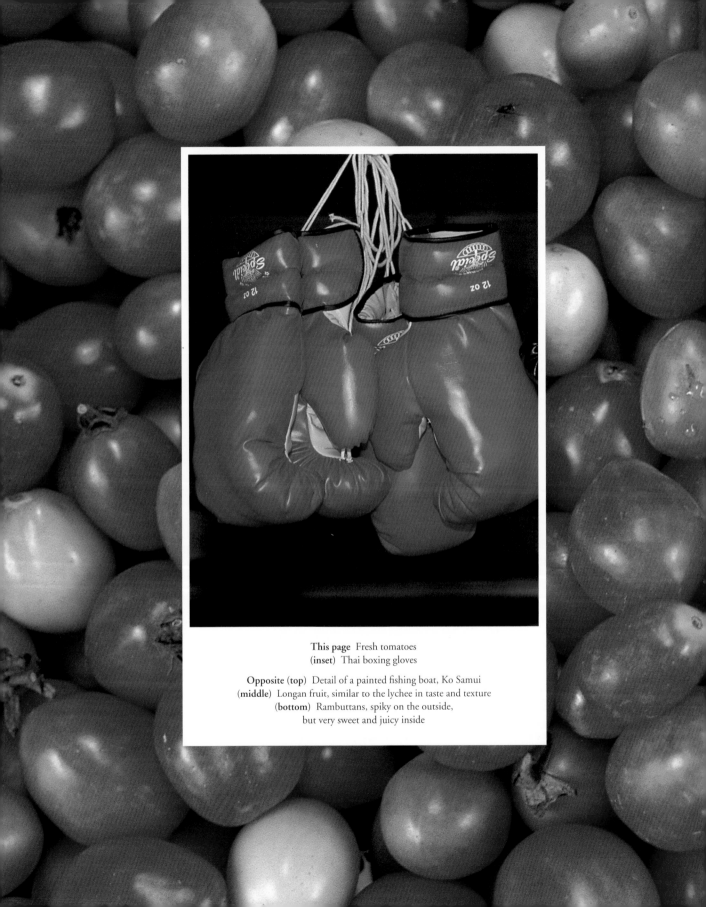

This page Fresh tomatoes
(**inset**) Thai boxing gloves

Opposite (**top**) Detail of a painted fishing boat, Ko Samui
(**middle**) Longan fruit, similar to the lychee in taste and texture
(**bottom**) Rambuttans, spiky on the outside,
but very sweet and juicy inside

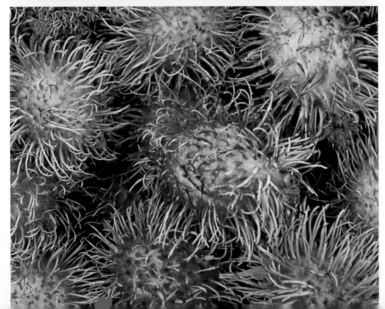

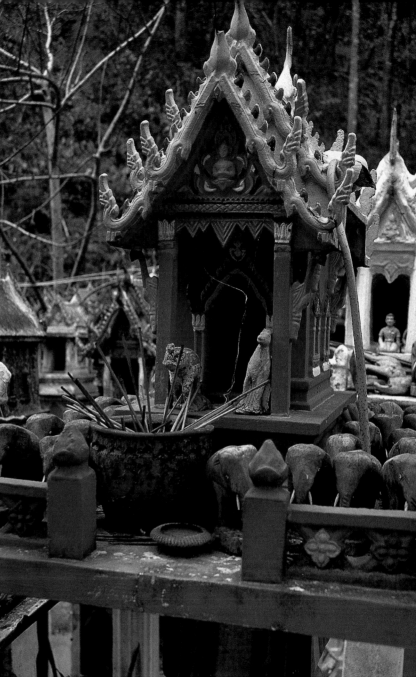

Opposite The *lingam* (phallus) shrine in Nai Loet Park, Bangkok. Infertile men, or families hoping for sons, donate *lingams* to this holy place

Above A spirit house outside Chiang Mai, Northern Provinces

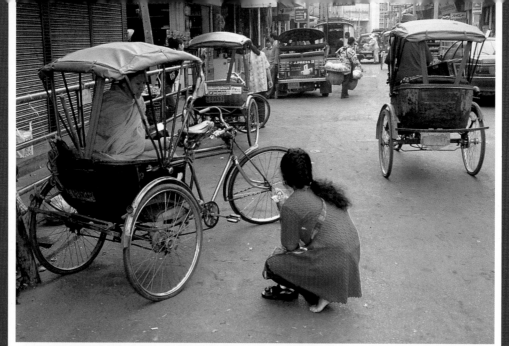

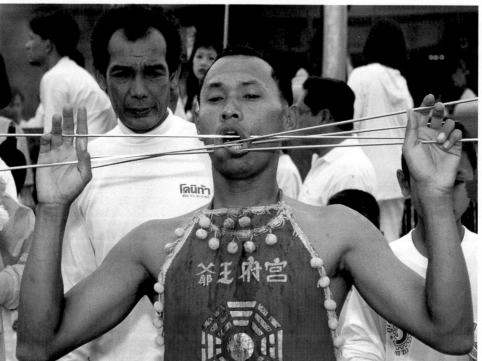

Top A monk gives absolution and receives alms from a woman, Chiang Rai, northern Thailand

Bottom A penitent during the Phuket Vegetarian Festival, who has pierced his cheeks with fine steel rods

Opposite Kick-boxer warming up for his forthcoming fight

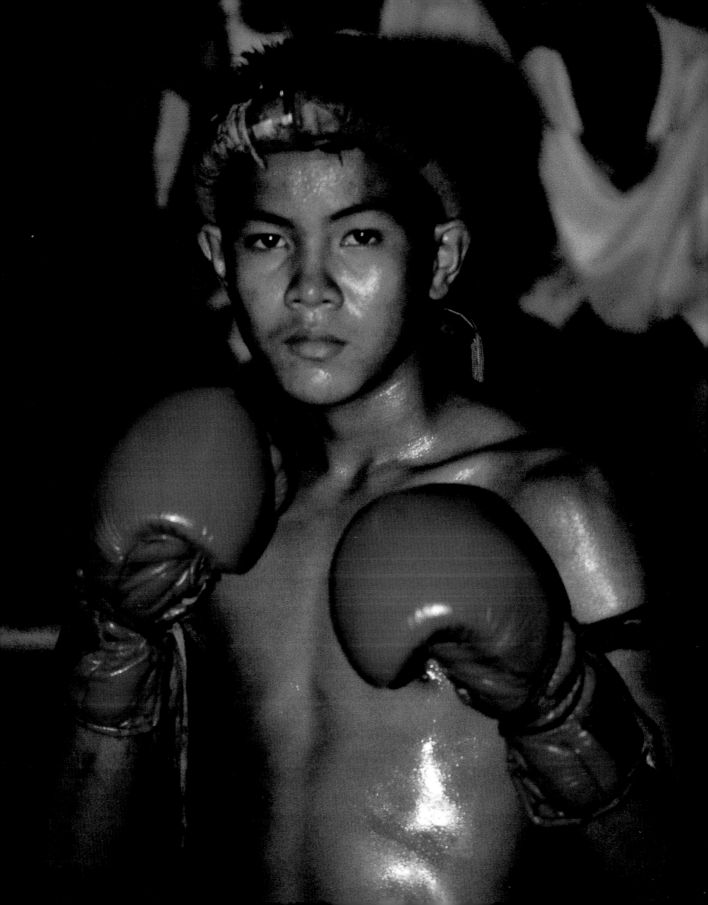

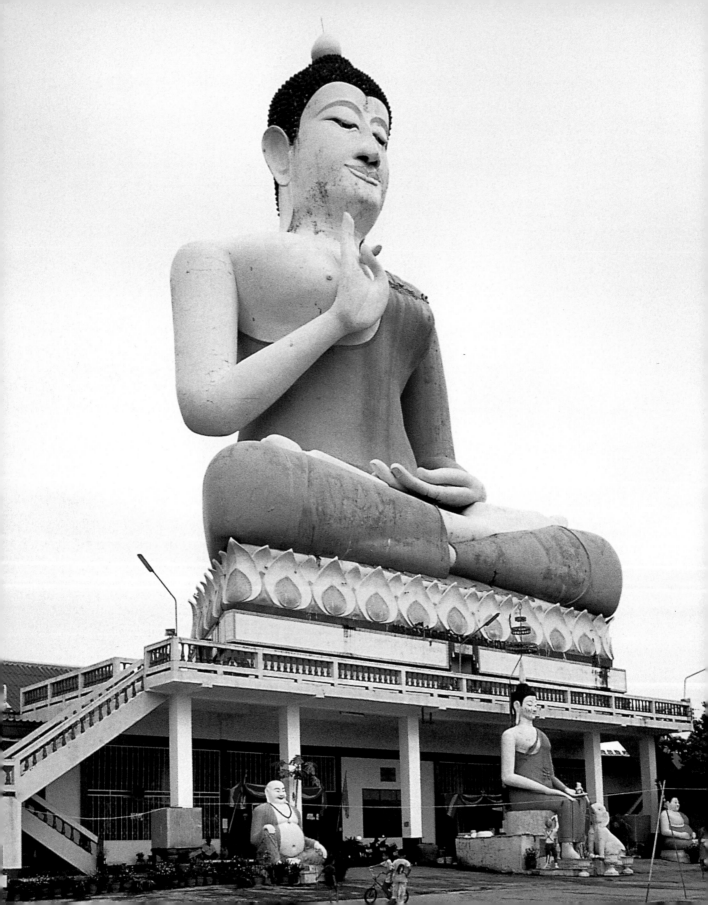

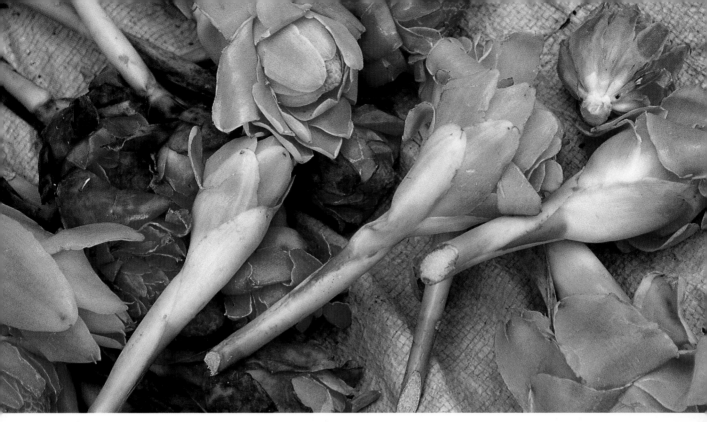

Opposite Buddha image seated on top of a modern temple complex, Uthan Thani Province

Above and below Lotus flowers for devotions and home decoration

Following pages Squid drying in the morning sun at a beach on Ko Samui

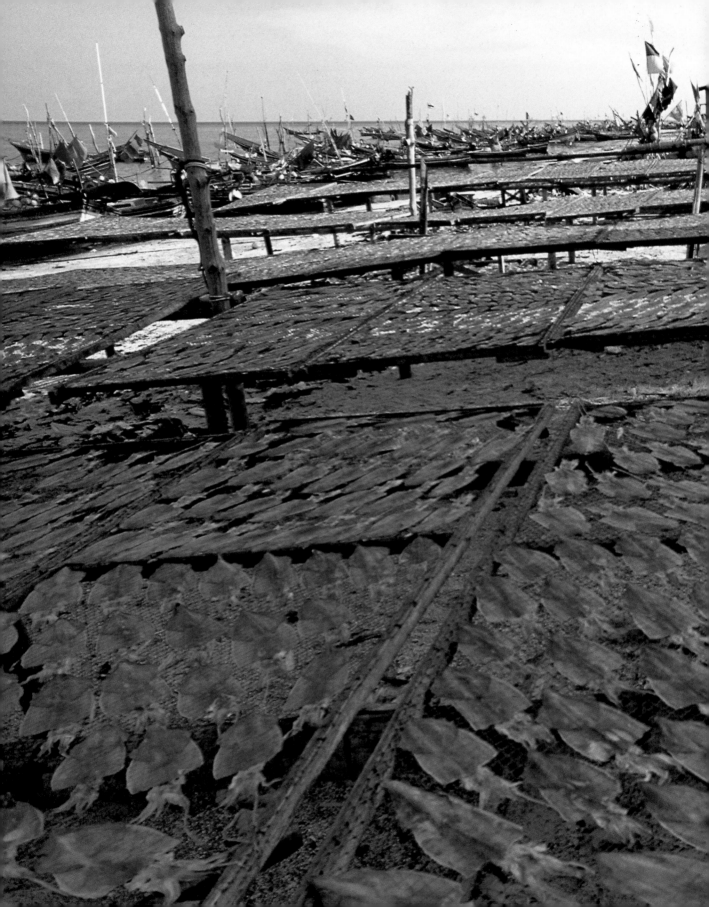

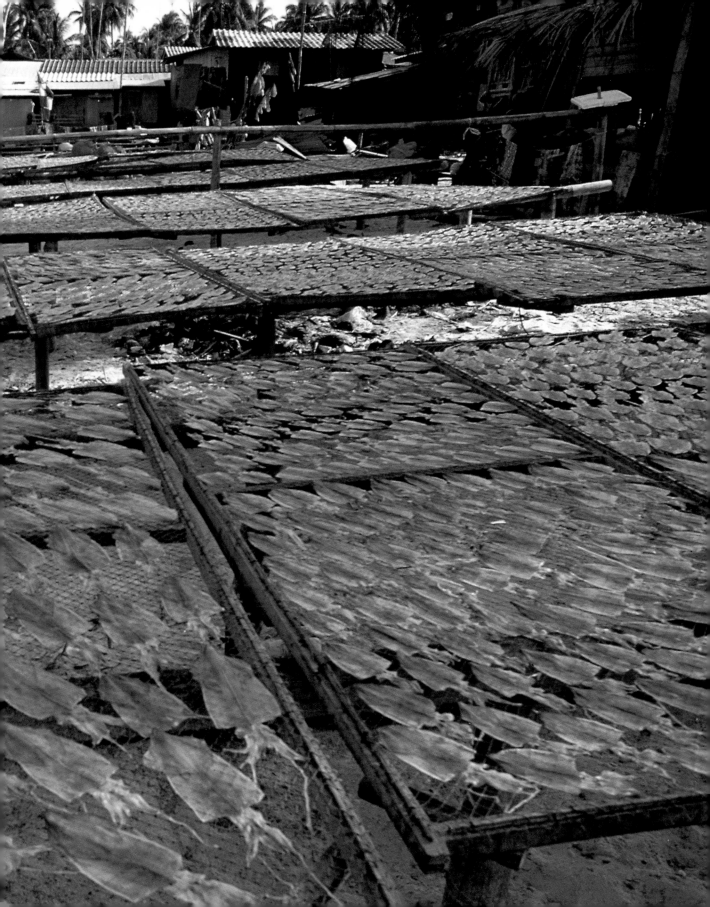

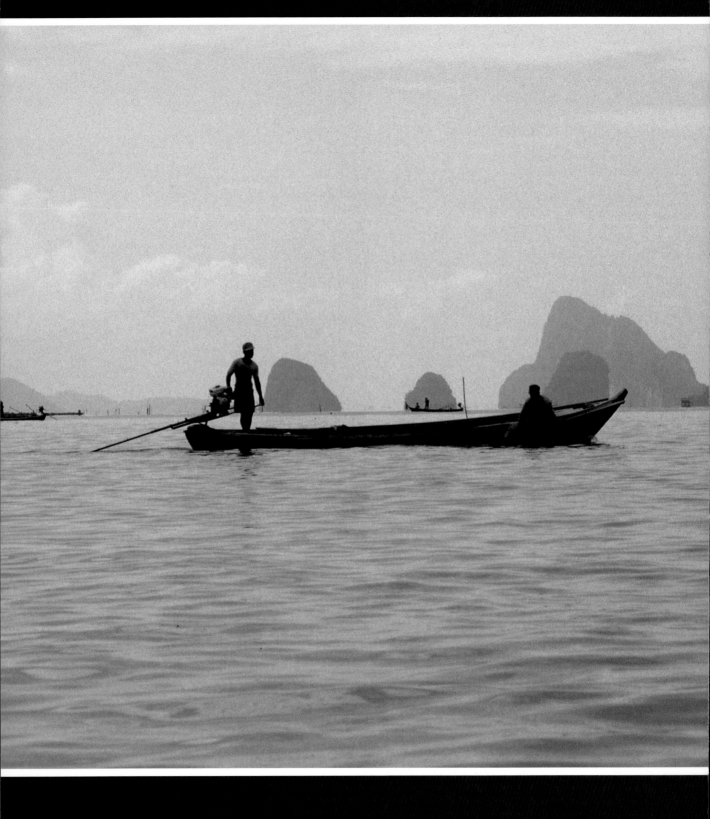

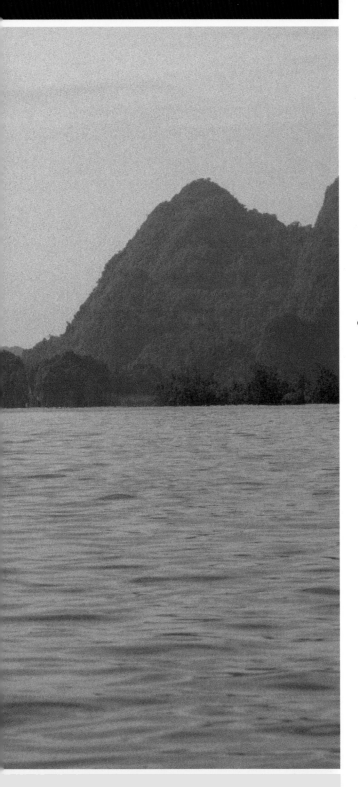

5.
Blue

W**HERE THE SEA** meets the sky. Thailand's beautiful waters are at the same time soothing and exciting. Sometimes the water is so pure and sweet that the urge to plunge in is overwhelming. The inland waterways, the arteries of the country, bustle with activity – and they link remote areas. Boat taxis, ferries and buses are commonplace. Endless blue skies are brushed with puffs of white cloud. Blue is a national colour, appearing in formal costume, and in Thailand's flag. Reflections of this unique deep azure are everywhere.

A fishing boat in the early morning in Phang Nga Bay, southern Thailand

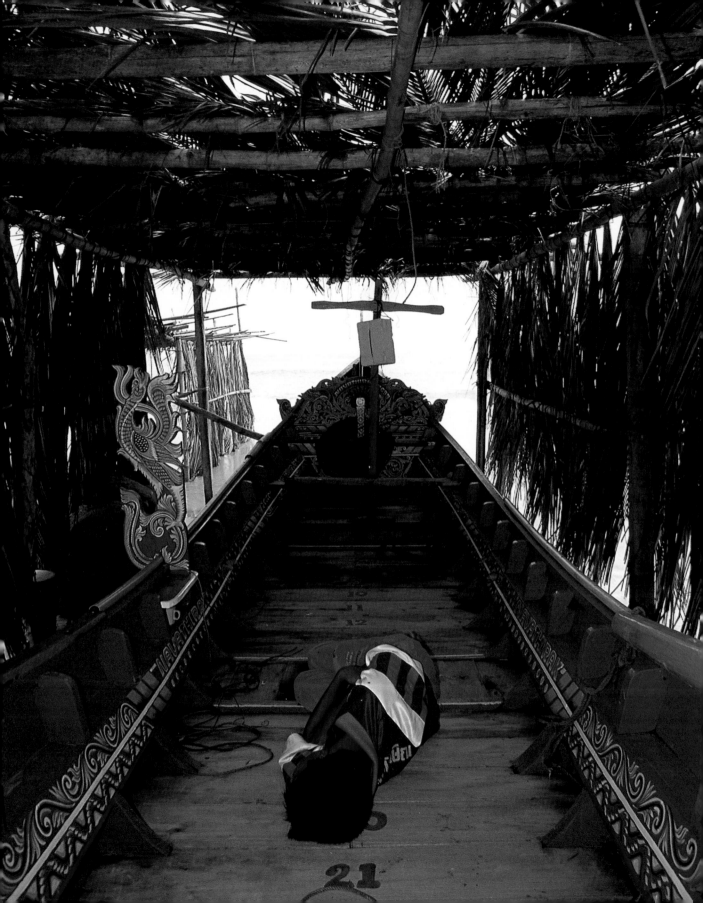

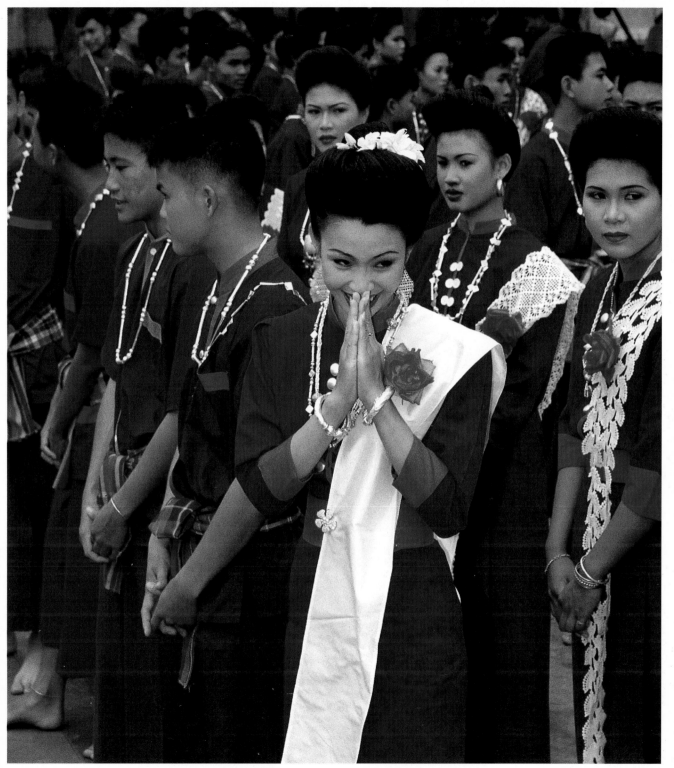

Opposite Fisherboy resting on his *reua kaw lae* (painted boat), Songkla Province

Above The traditional *wai* greeting, performed at a dance festival

Following pages Ferry boats on the River Kra at Ranong, on the border with Laos.
There is a constant traffic of shoppers crossing to and fro

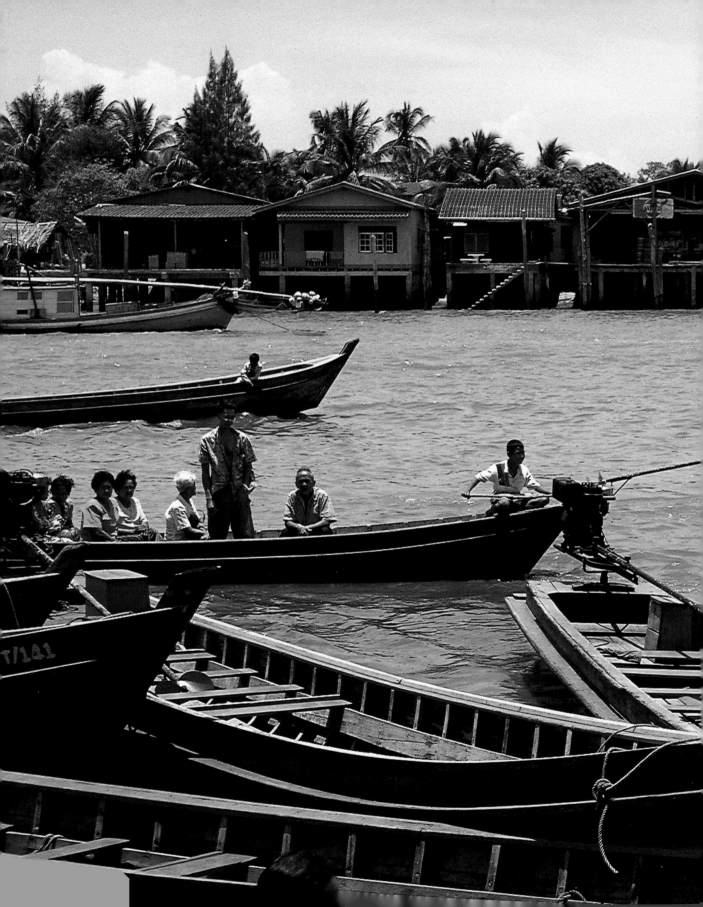

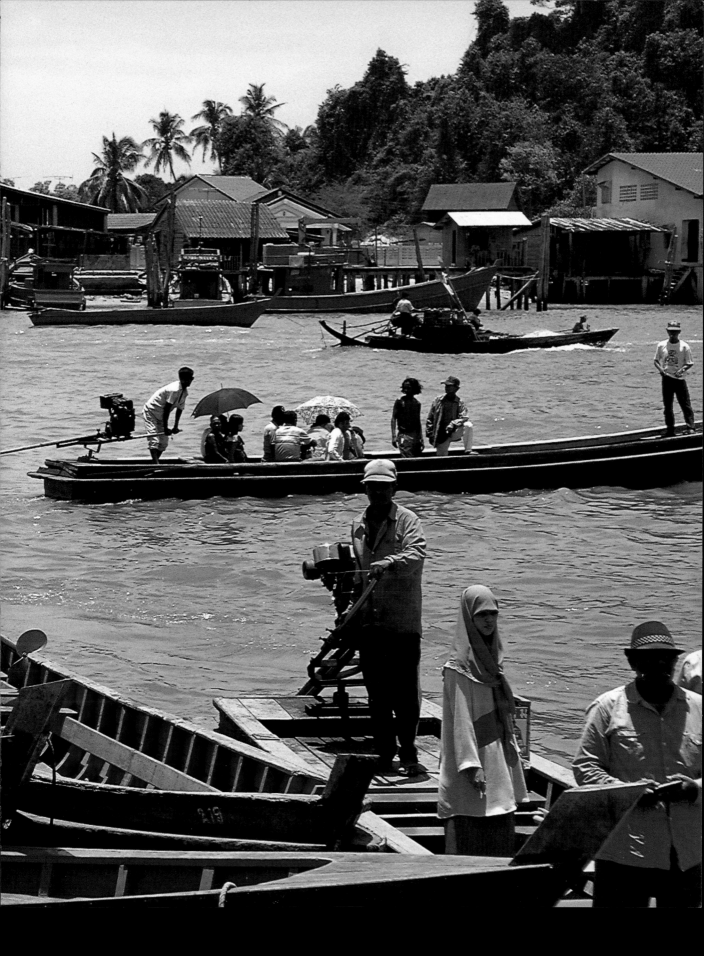

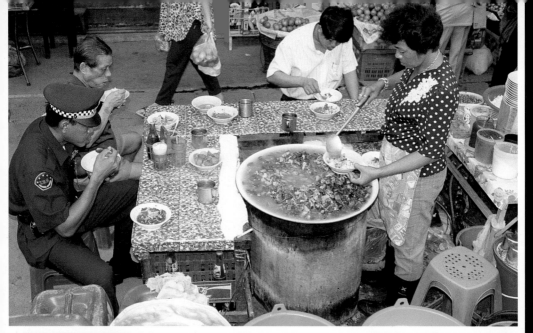

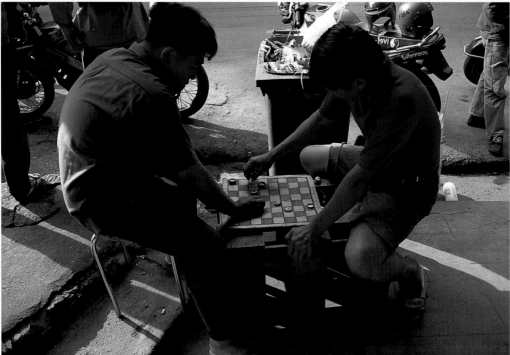

Top Lunchtime on the streets of Bangkok – Thais are always in a hurry and will only stop
for a short time to eat

Bottom A game of draughts on a crowded pavement in Bangkok

Opposite Moon over the magnificent ruins of Sukhotai during the Loy Kratong Festival,
held at full moon in November

Following pages Elephant bathing with his *mahoot* (keeper) during the Surin Elephant Roundup
(inset) Women fishing in a sweetwater pond by the roadside in Buri Ram Province

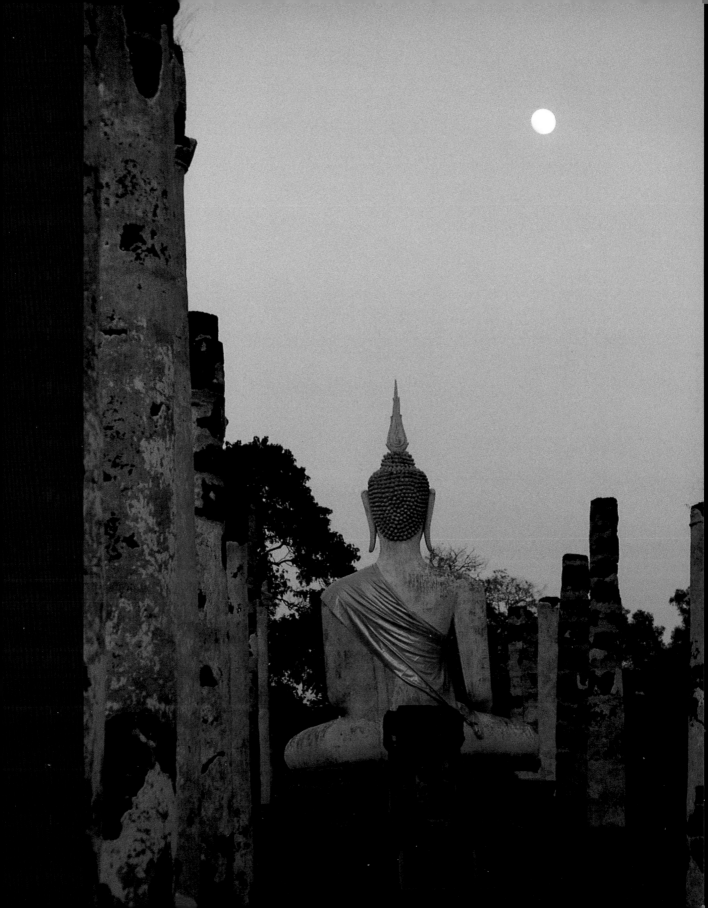

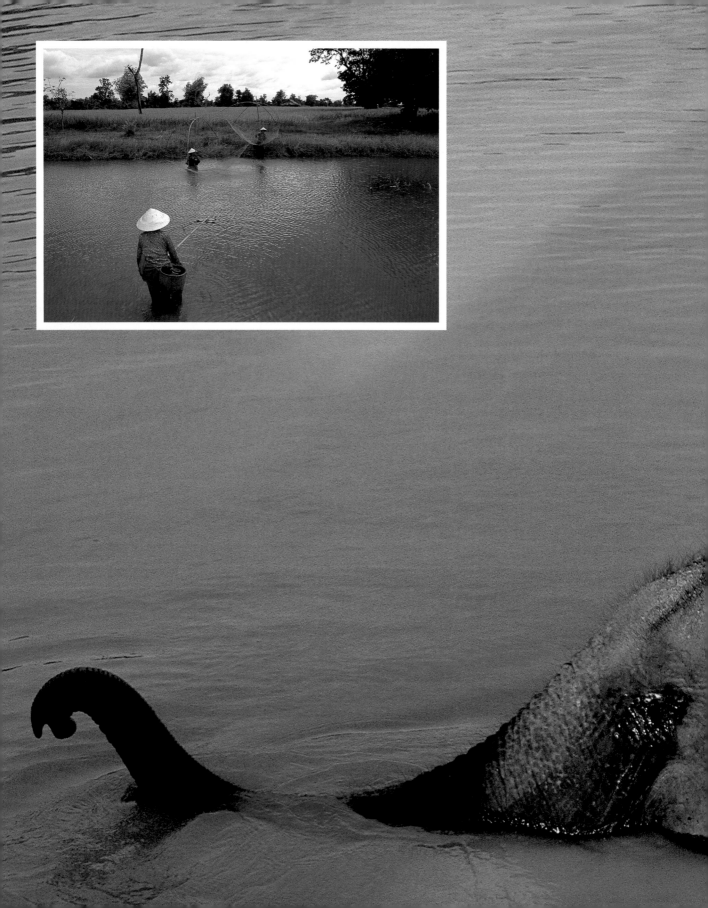

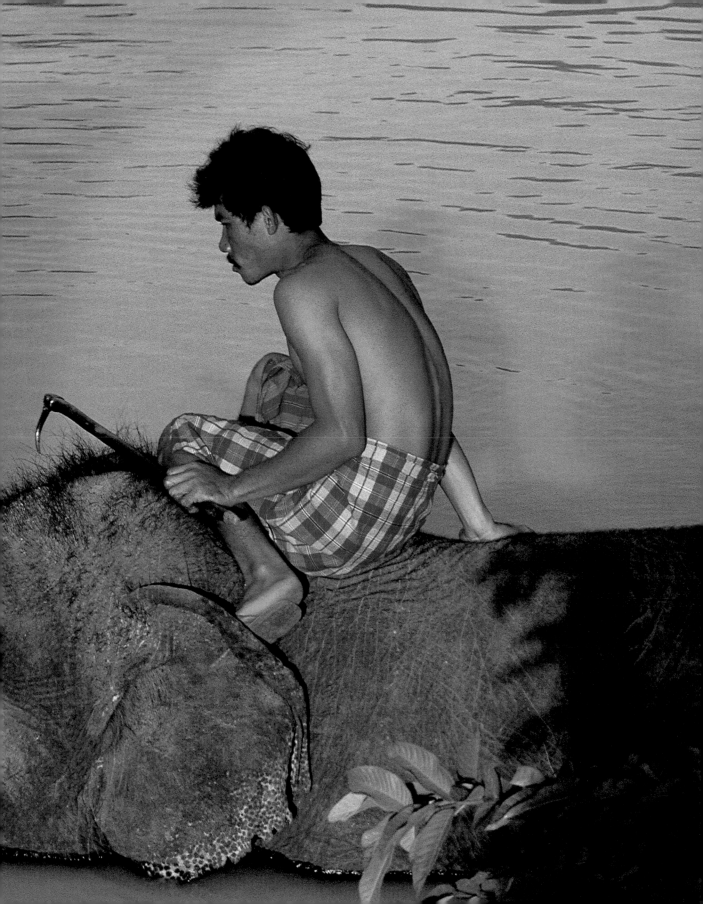

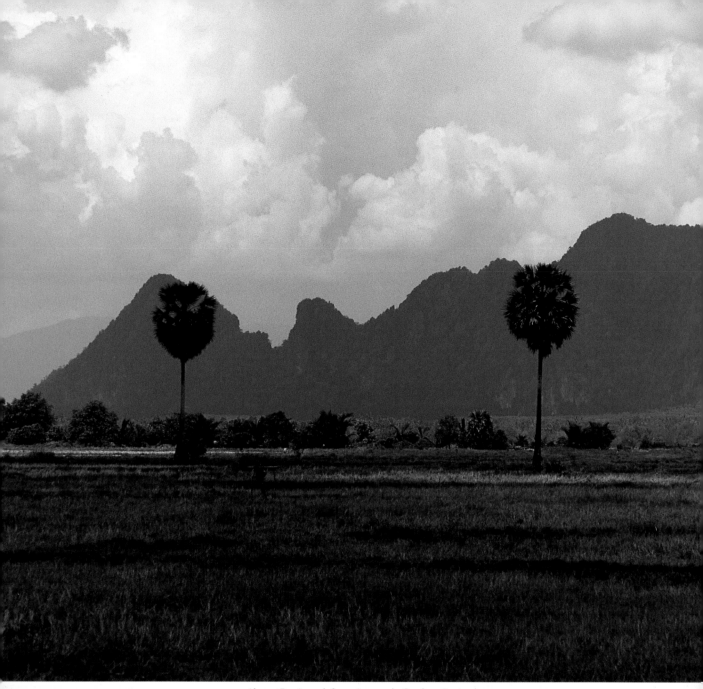

Above Granite rock formations on the Southern Peninsula

Opposite (**above**) Bridge to the fishing boats' dock, early morning at Prachuap Khiri Khan, southeast Thailand
(**below**) Beach and tourist boats at Ang Thong National Marine Park, Ko Samui

Following pages Early morning Bangkok, seen from its new bridge

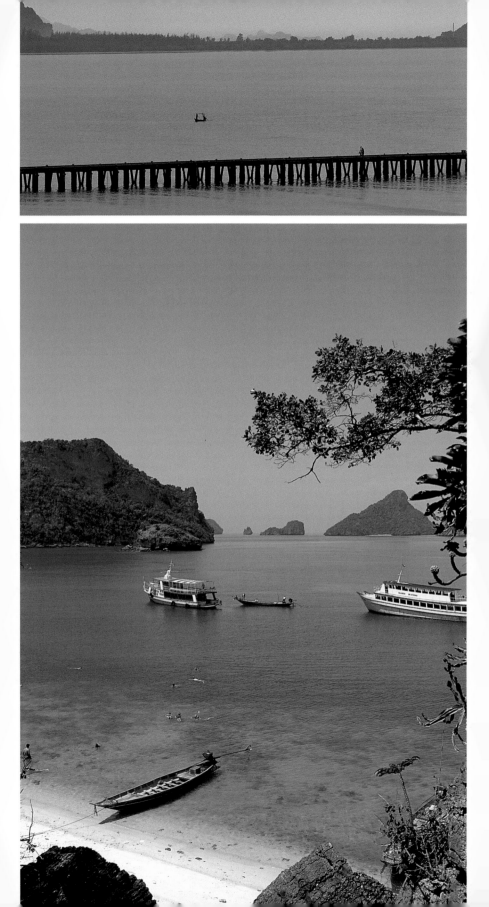

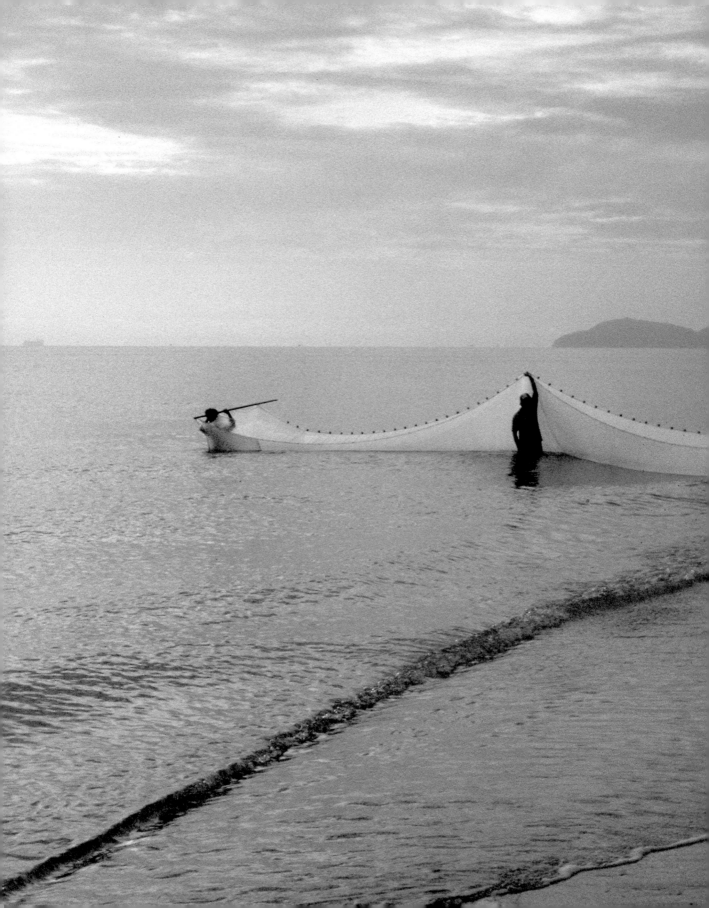

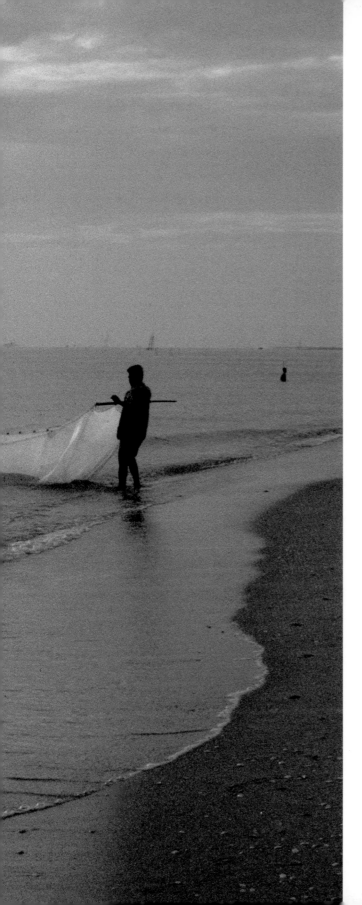

6.

Silver-White

Pure, clean and crisp, the cool early morning light is refreshing before the heat of the day. Smiling faces – the 'sea gypsy boys' with their rice-powder paint poke fun at the *farang*. Stately Akha matrons with their silver headdresses and pipes gaze on benevolently. A novice monk takes his vows in front of family and senior monks. Dressed in white, his head also painted with rice powder, he is pure in front of his Lord Buddha. Sparkling fish just plucked from the deep, jewels of the Gulf of Thailand and the Andaman Sea. Conical mounds of rock salt drying in the sun – salt of the earth, essence of life.

Early morning on the beach at Songkla – fishermen trawling with fine nets for krill

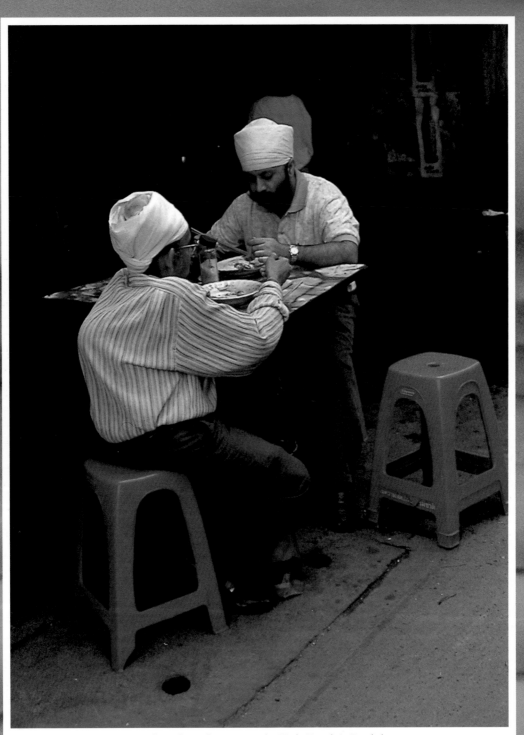

Thai Indians taking tea near the Hindu Temple in Bangkok

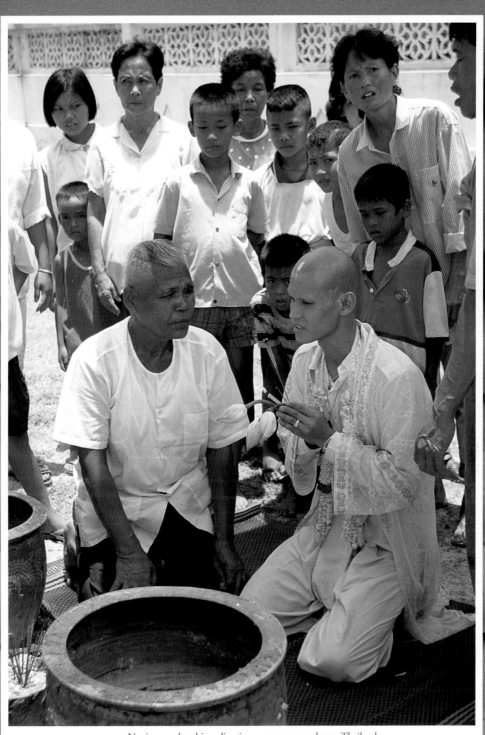

Novice monk at his ordination ceremony, northwest Thailand

Background Virgin rubber tapped from the trees, Phuket

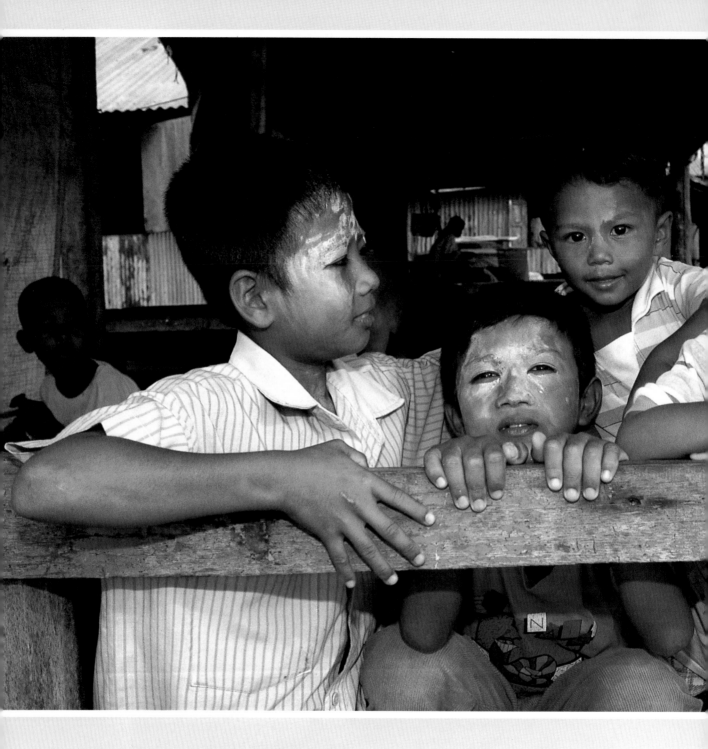

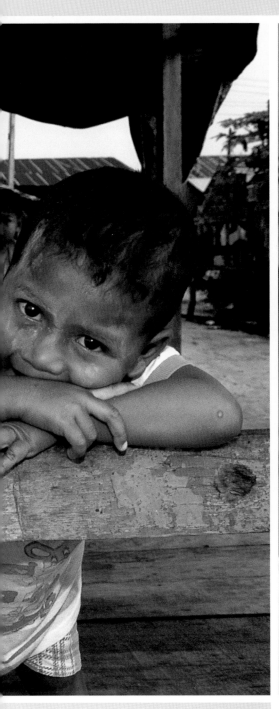

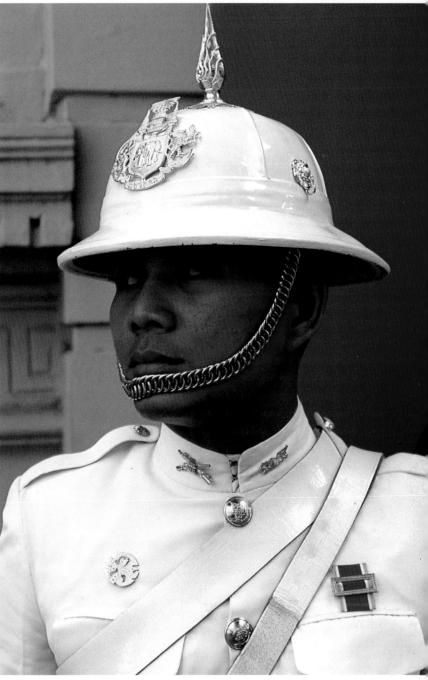

Left *Chao le* (sea gypsy) children, painted with rice powder, Phuket

Above Guard at the Royal Palace, Bangkok

Following pages Fresh, glistening fish in the market, Surat Thani, Southeastern Provinces

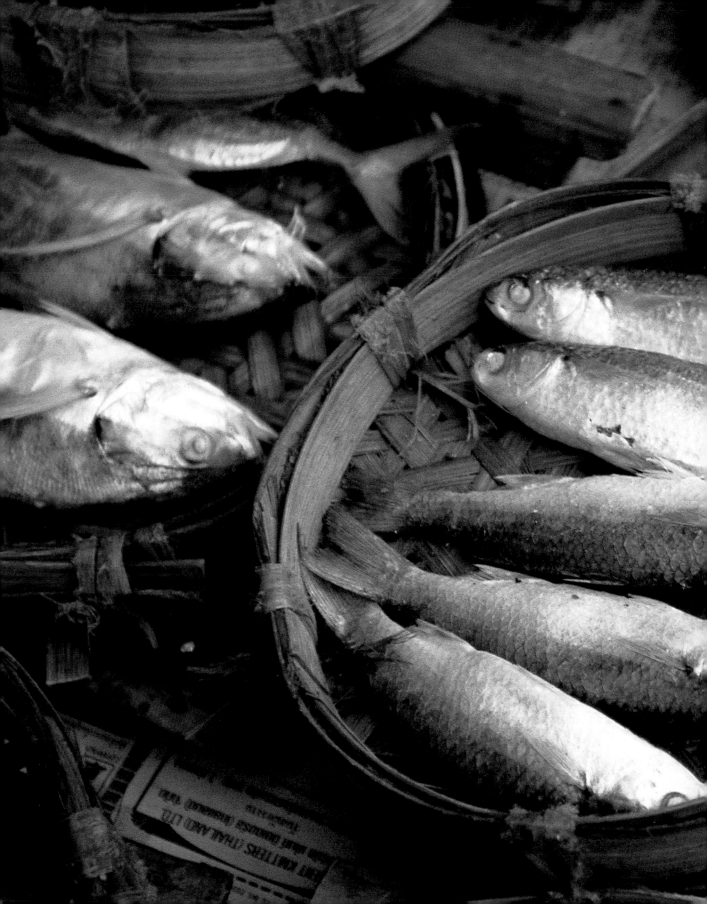

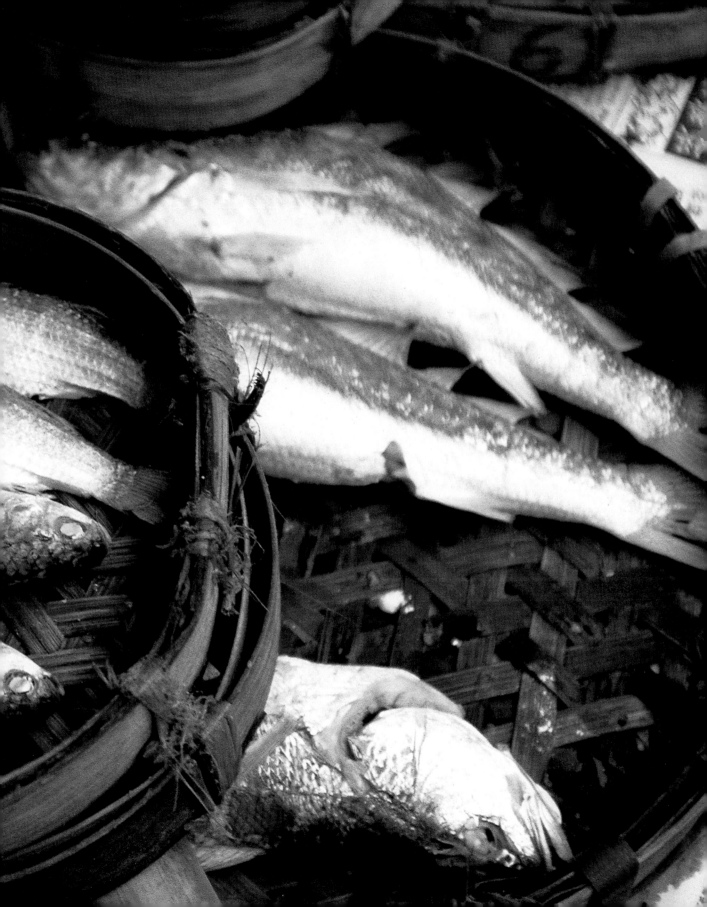

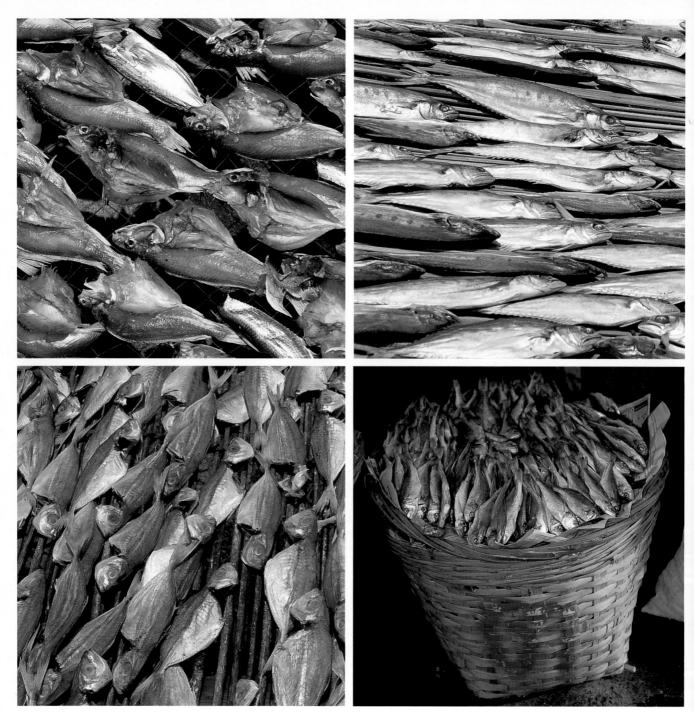

Above and opposite Freshly caught fish

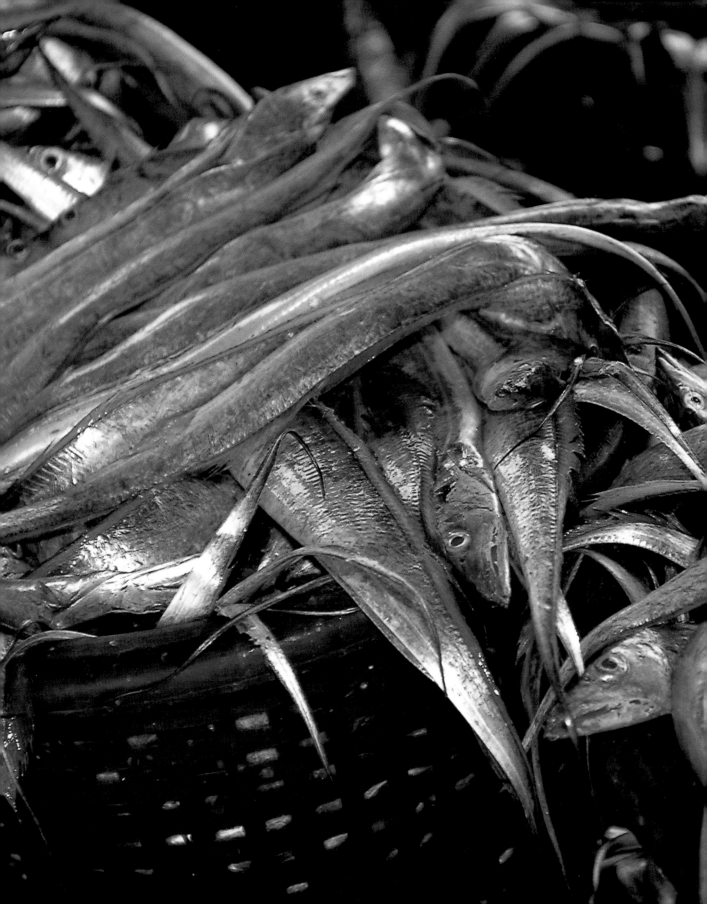

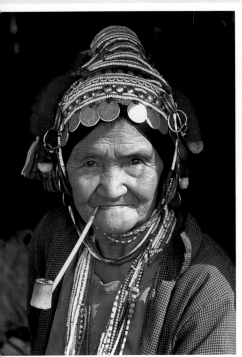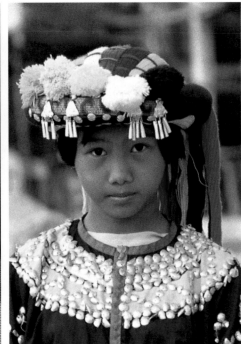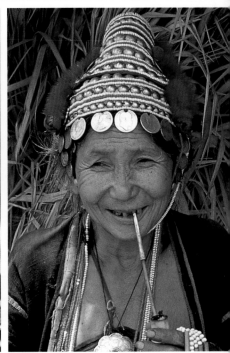

Above (left) Akha woman, northwest Thailand
(centre) Akha girl by the Mekong River, northwest Thailand
(right) Akha woman, northern Thailand

Opposite Muslim boy in the fishing village at Ko Samui, southeastern Thailand

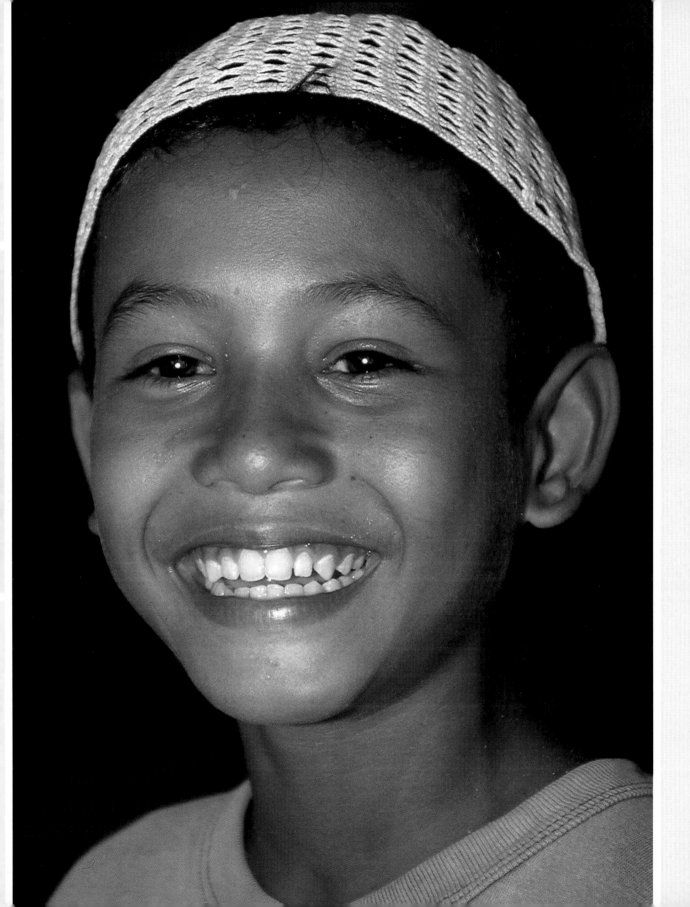

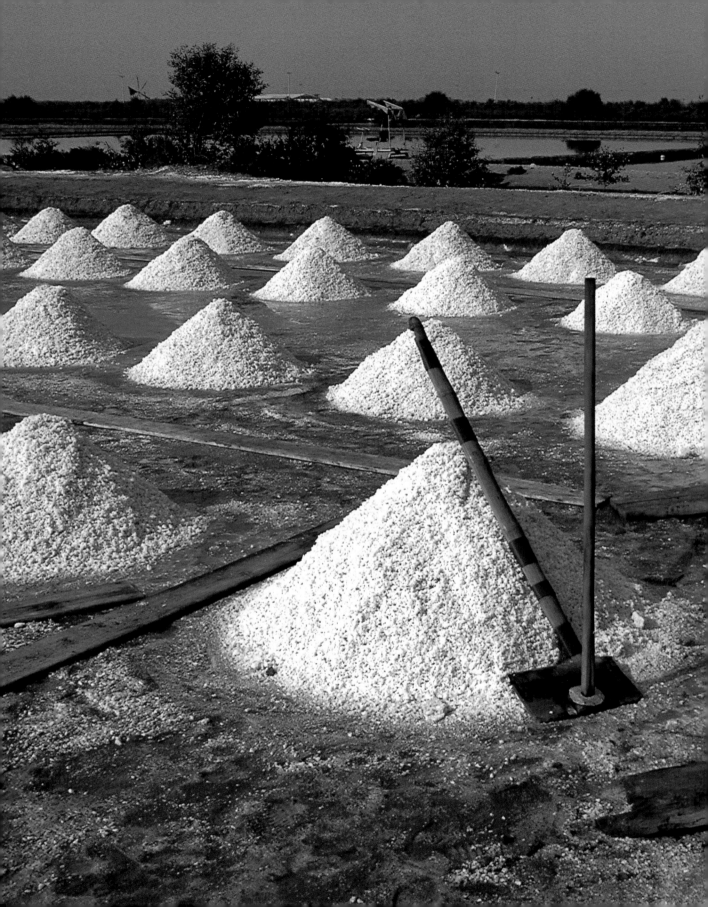

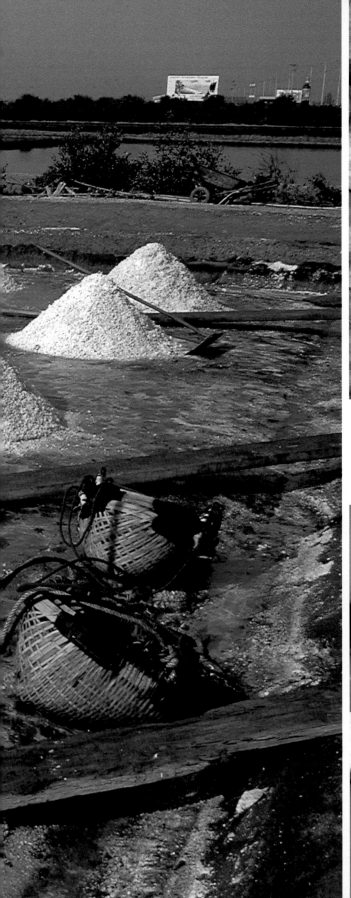

Left Rock salt drying in the salt fields south of Bangkok

Above Fresh garlic

Below Coconuts in the market, cut ready for drinking

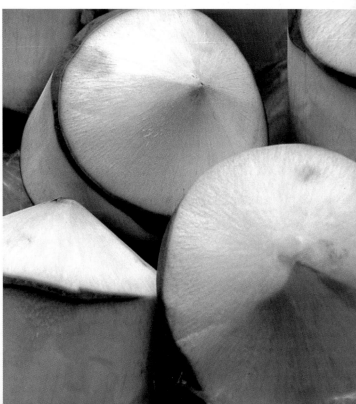

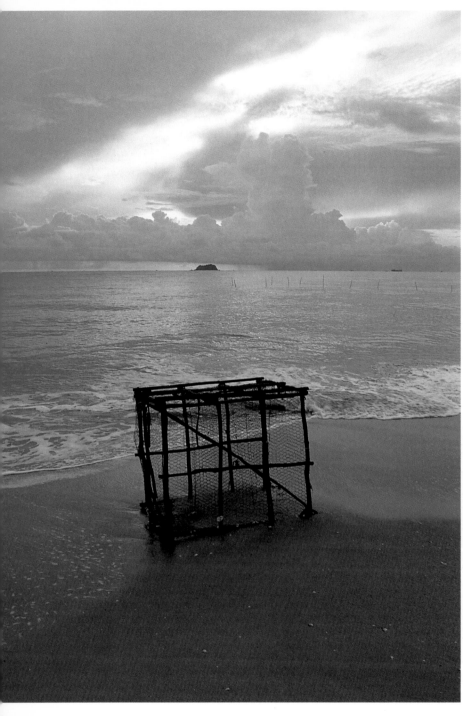

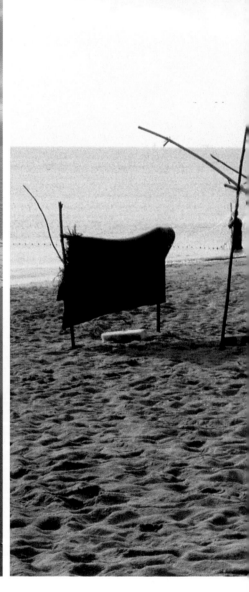

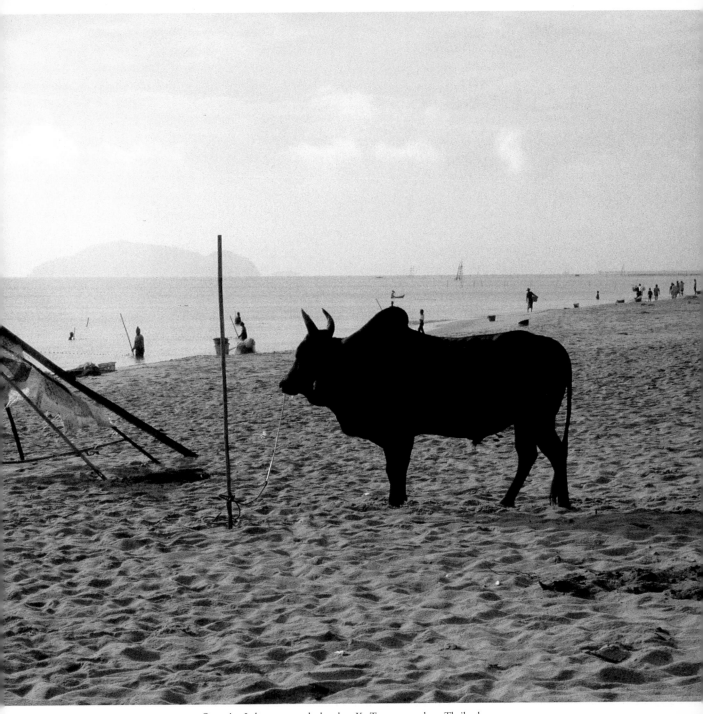

Opposite Lobster pot on the beach at Ko Tarutao, southern Thailand

Above Bull on the beach at Songkla, Southeastern Provinces

Following pages A line of Seated Buddhas at Ayuthaya, Central Plains

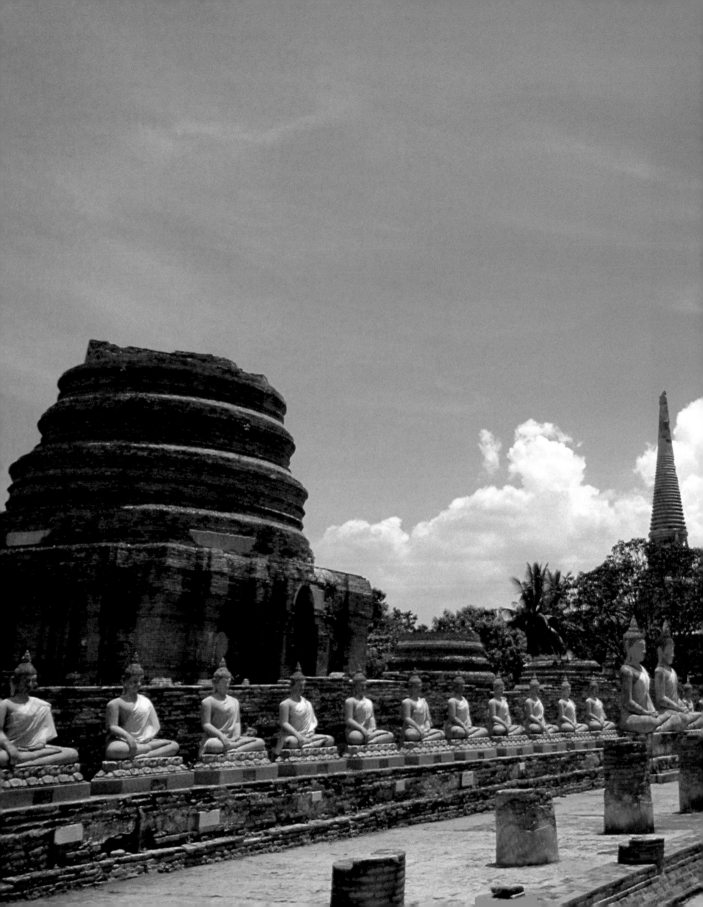

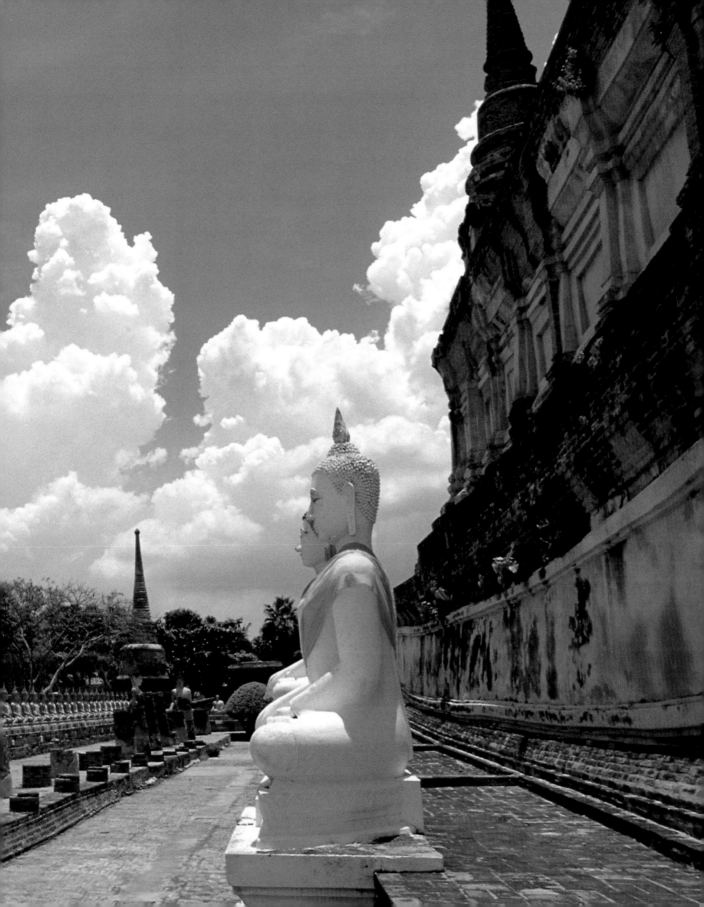

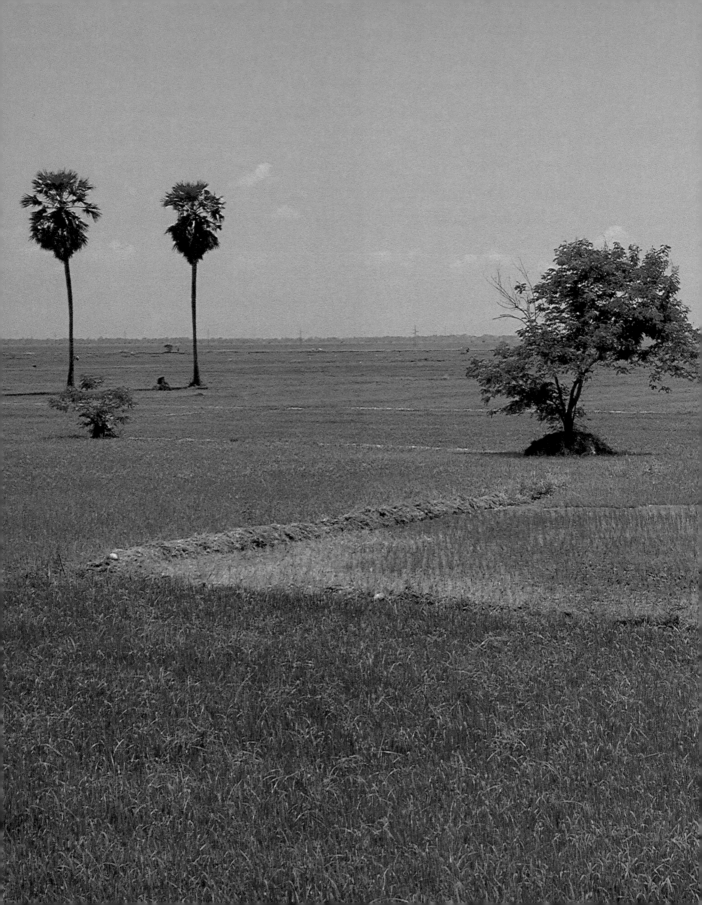

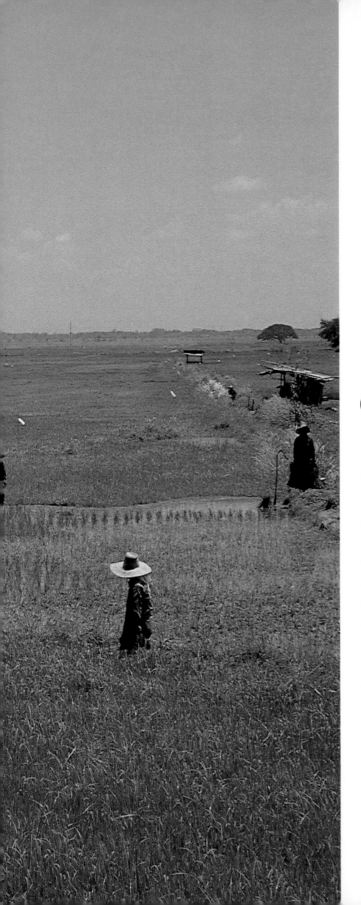

7.

Green

VERDANT RICE sways in the breeze. The dark greens of these carefully tended crops indicate a readiness for picking. The staple diet of the Thai people, they are completely self-sufficient in this essential crop. In the markets, so many different shapes and textures abound: aubergine, coconuts, giant bean pods, the huge green-lipped mussel. Everywhere, vivid green waters of ponds with their millions of budding lily pods. Sometimes the sea shows her darker side, lying in the shadow of the granite outcrops around Phang Nga Bay, Phuket.

Harvesting the rice, Isan Province, northeast Thailand

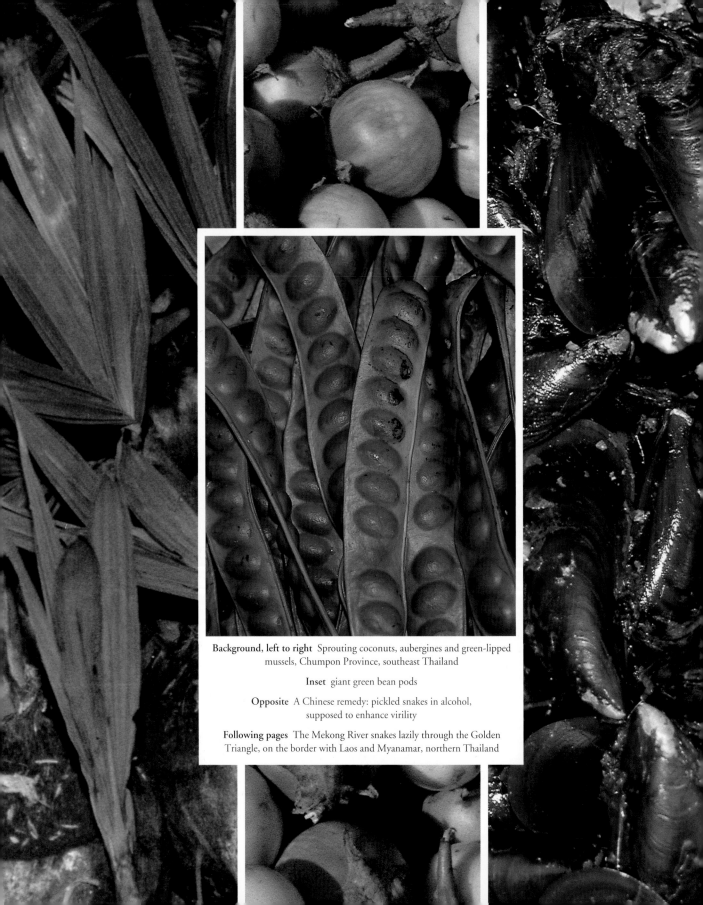

Background, left to right Sprouting coconuts, aubergines and green-lipped mussels, Chumpon Province, southeast Thailand

Inset giant green bean pods

Opposite A Chinese remedy: pickled snakes in alcohol, supposed to enhance virility

Following pages The Mekong River snakes lazily through the Golden Triangle, on the border with Laos and Myanamar, northern Thailand

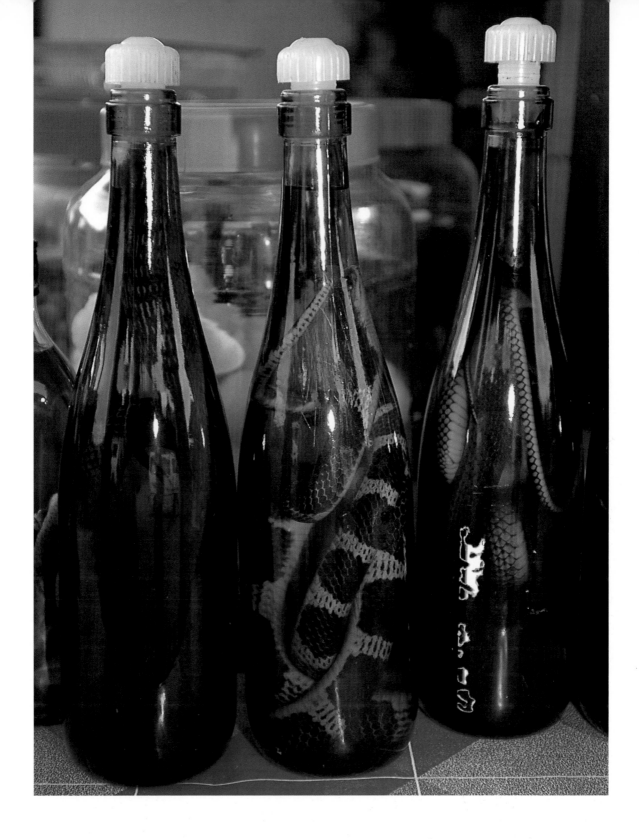

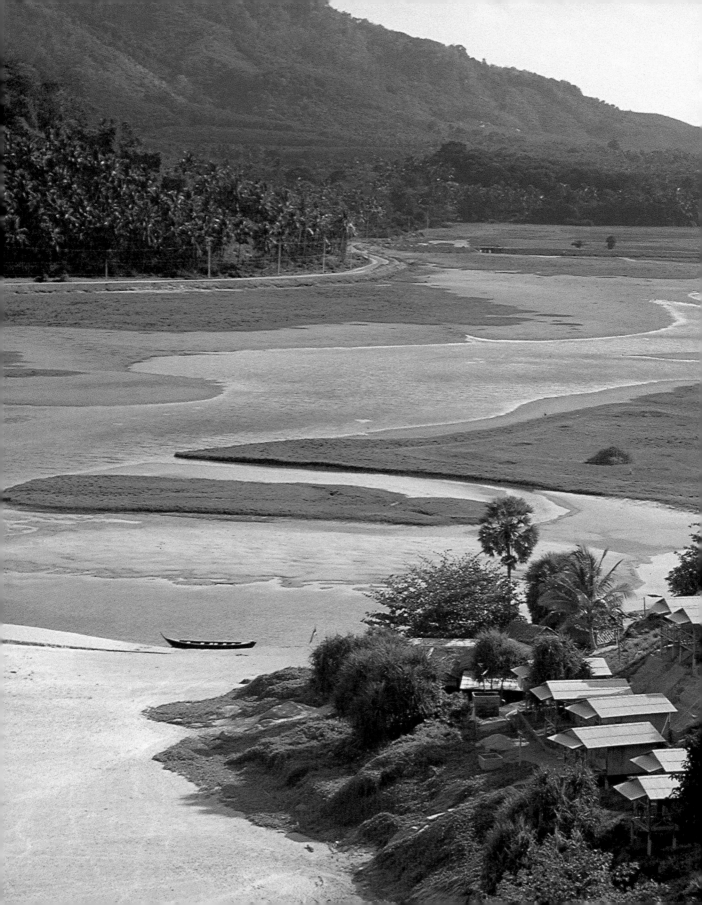

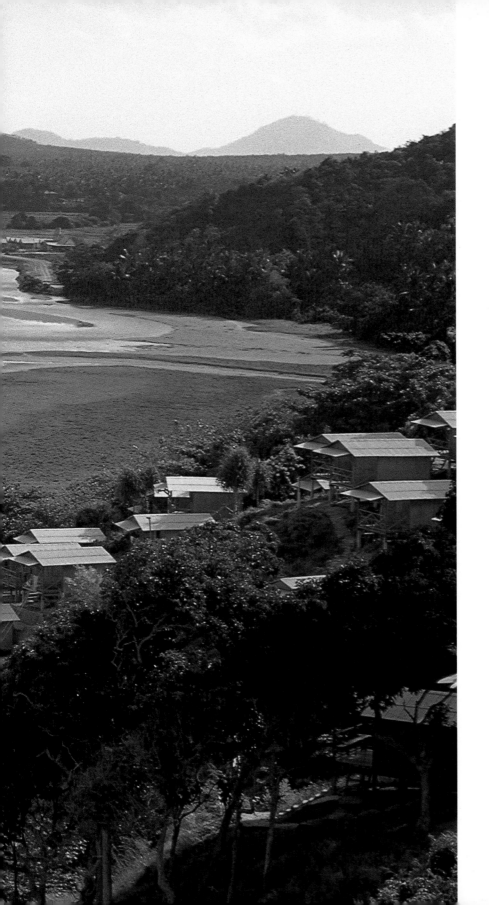

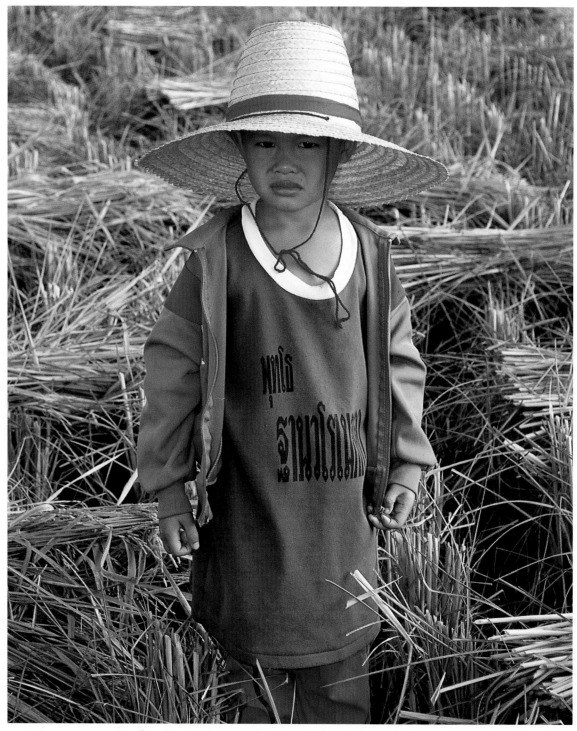

Above Young assistant at the rice harvest, Sukhotai Province, Central Plains

Opposite Farmer, Mae Hong Son Province, northwest Thailand

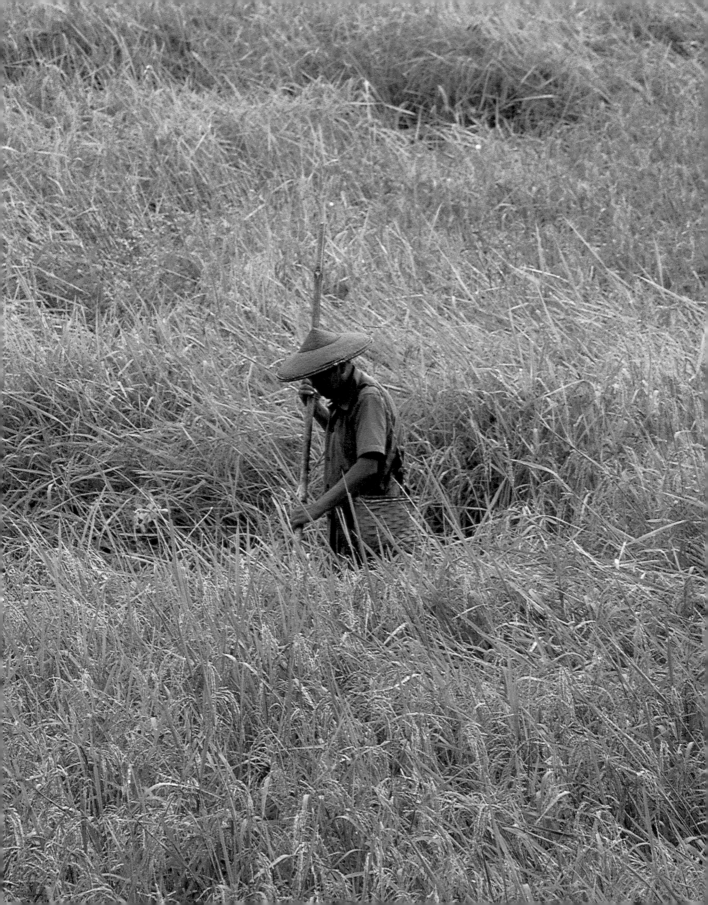

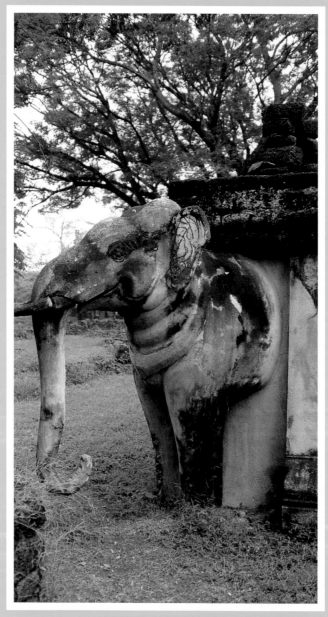

Above Wat Chang Rop at Kamphaeng Phet, one of the old cities
of the Sukhotai kingdom, Central Plains

Opposite Doorway at the Khmer ruins at
Phanom Wat Prasat, Central Plains

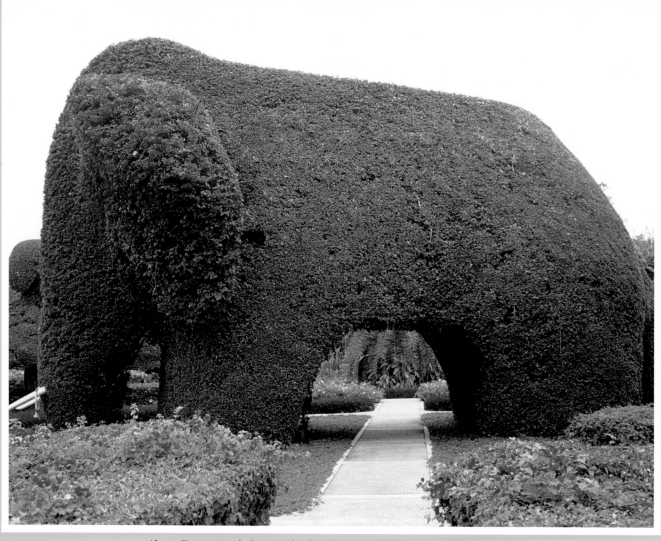

Above Giant topiary elephant, interlaced with bougainvillea, Hua Hin, southeast Thailand

Opposite (top) Watermelons, aubergines and coolie hat. Floating market, Saduak, south of Bangkok
(bottom left) Fish feeding frenzy, Phi Phi Leh, off Ko Phuket, southwest Thailand
(bottom right) Brooms made by Laotian refugees drying in the sun

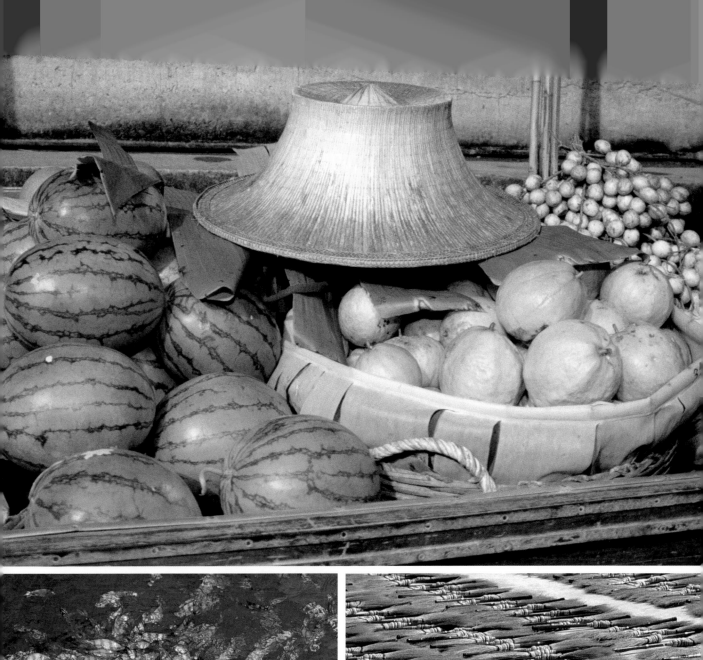

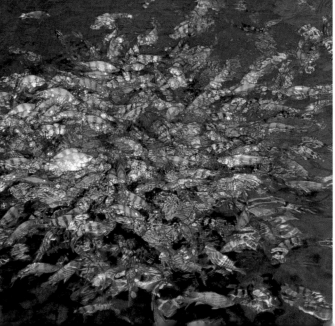

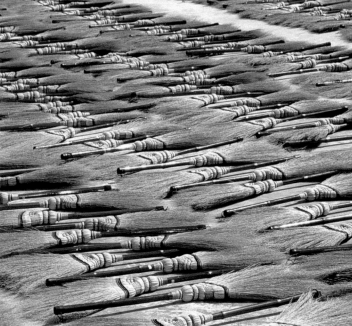

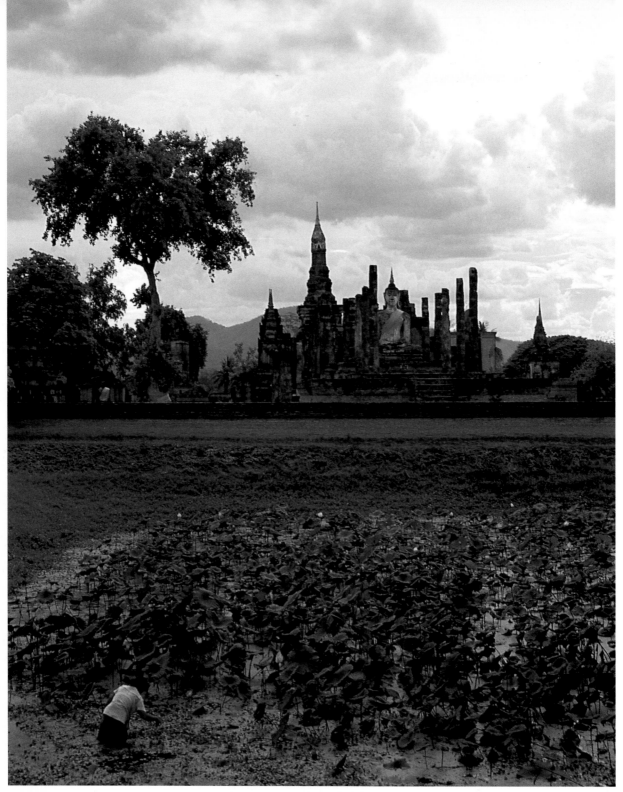

Above The ruins at Sukhotai, Central Plains

Opposite Monks on Phi Phi Island, Phuket Province, southwest Thailand

Following pages Monkey Mountain, Srisatchanalai National Park, Central Plains,
recently saved by conservationists from mining developers

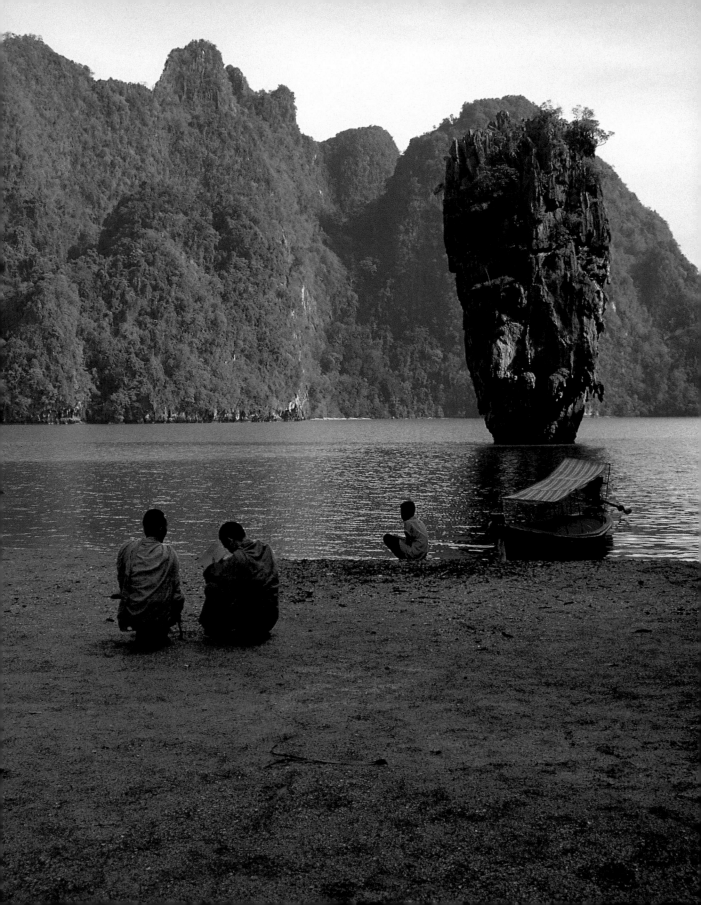

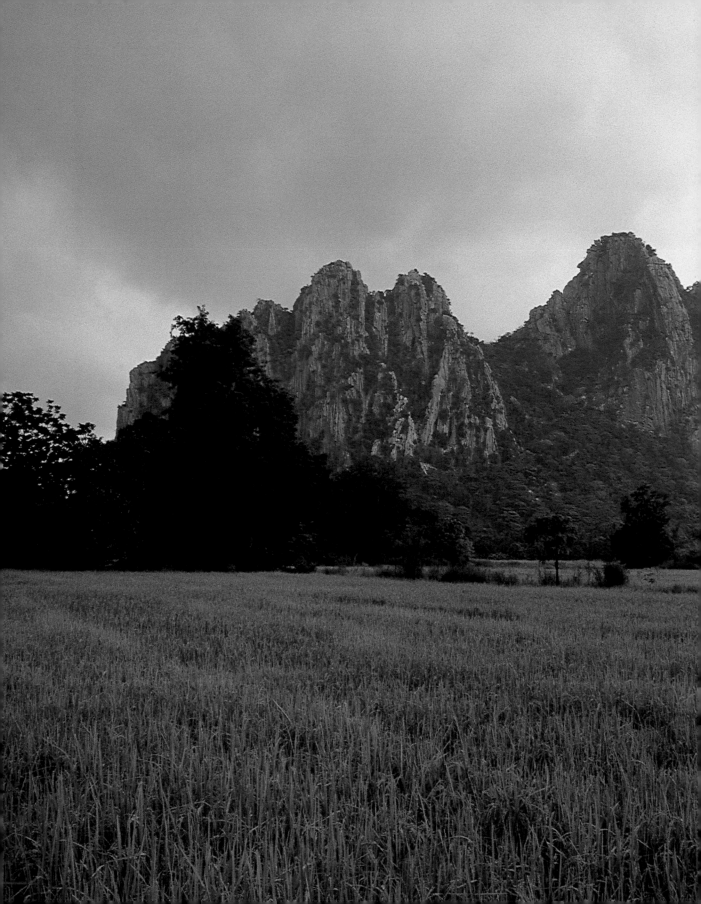

8.

Earth

Iɴ ᴛʜᴇ ᴅʀʏ sᴇᴀsoɴ Thailand's rivers are thin threads of sluggish umber. The soil is brown. When the waters rise, they run the same colour as its banks. Buildings are made from the mud itself. Houses are made of mud bricks, their roofs of dried leaves or grasses – everything seems to be totally homogenous. Ancient monuments from the Lanna, Sukhotai and Lopburi periods are made of baked mud or hewn out of sandstone, becoming almost indistinguishable from their surroundings. Farmers are as earthen as the land they work so meticulously. Only their teeth shine white through the grime.

Fisherman casting his net on the Mekong River, northern Thailand

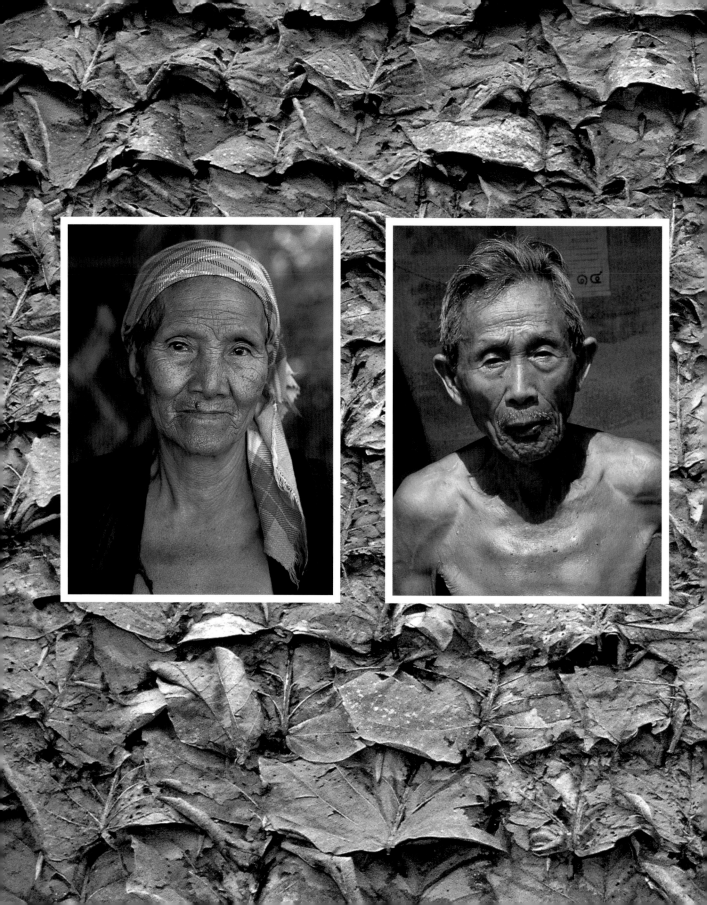

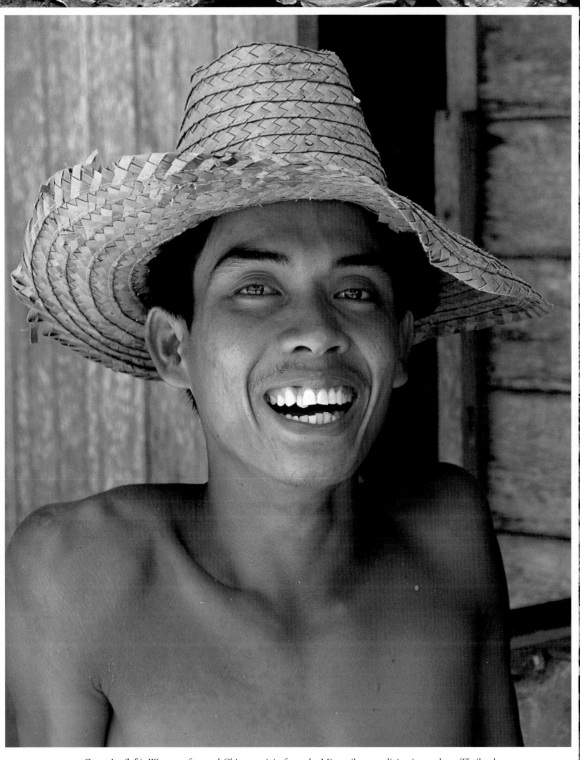

Opposite (left) Woman of central Chinese origin from the Mien tribe, now living in northern Thailand
(right) Man from Karen tribe, Northern Provinces

Above Muslim fisherman, Panare Province, southern Thailand

Background Detail of a hill-tribe village roof made of wooden tiles and leaves

Top Interior of a Thai home, with a shrine dedicated to kings of Thailand

Bottom Detail of the interior of Wat Jong Klang, Mae Hong Son – illustrated is the life of a monk

Opposite Wood carving detail, Phetburi

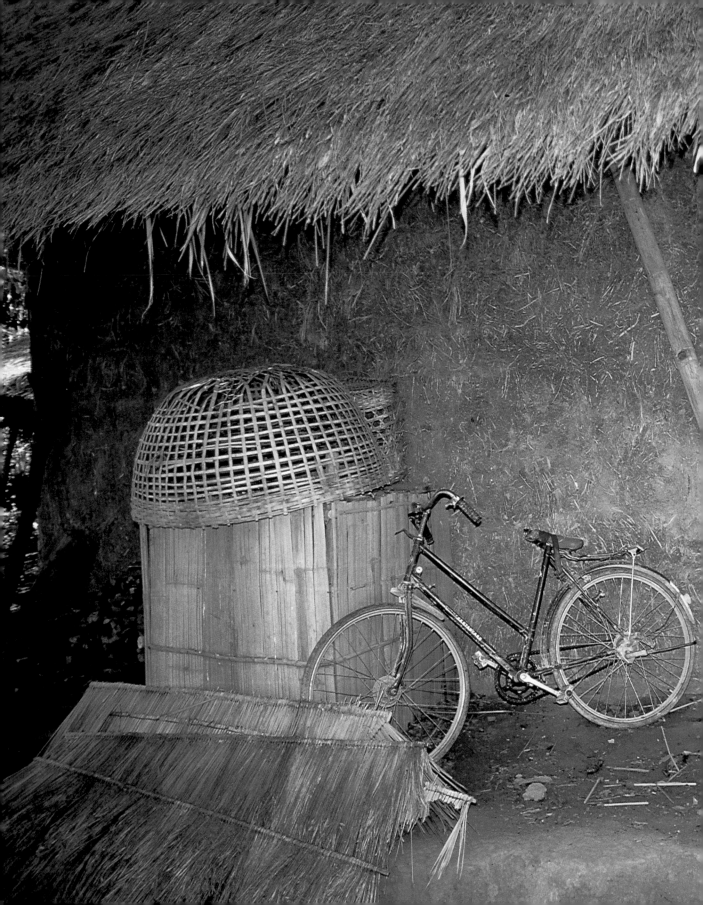

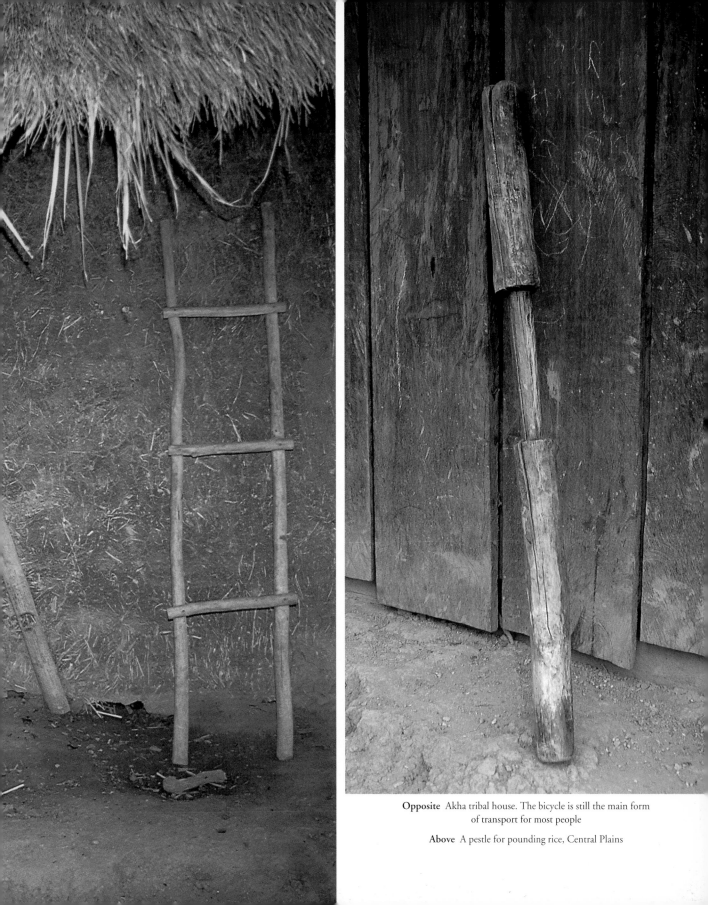

Opposite Akha tribal house. The bicycle is still the main form
of transport for most people

Above A pestle for pounding rice, Central Plains

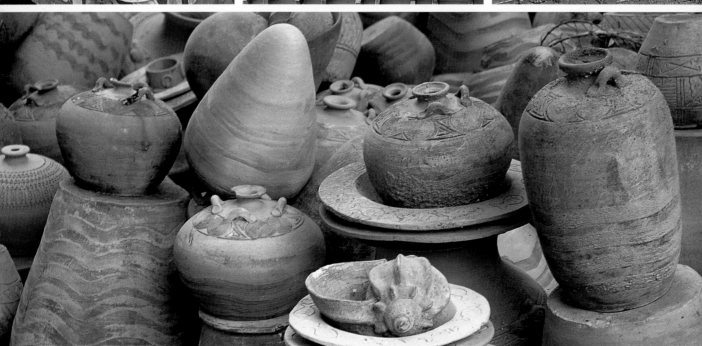

Top (left to right) Coolie hats for sale in Central Thailand;
wooden spirit houses, where the *phra phum* (earth spirits) of every building live;
sweetwater fish are kept fresh in wickerwork pots left standing in the water

Bottom Pottery village near Phitsanulok

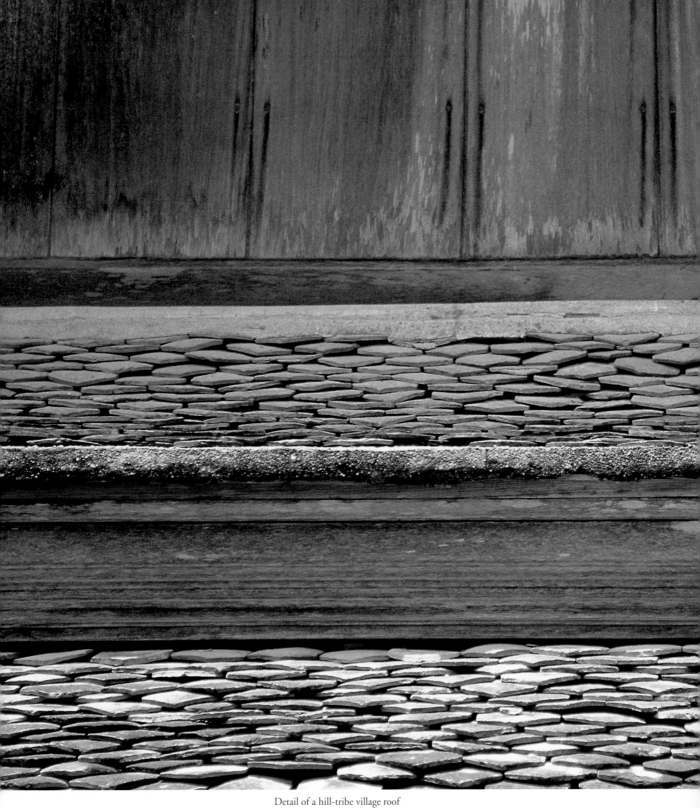

Detail of a hill-tribe village roof

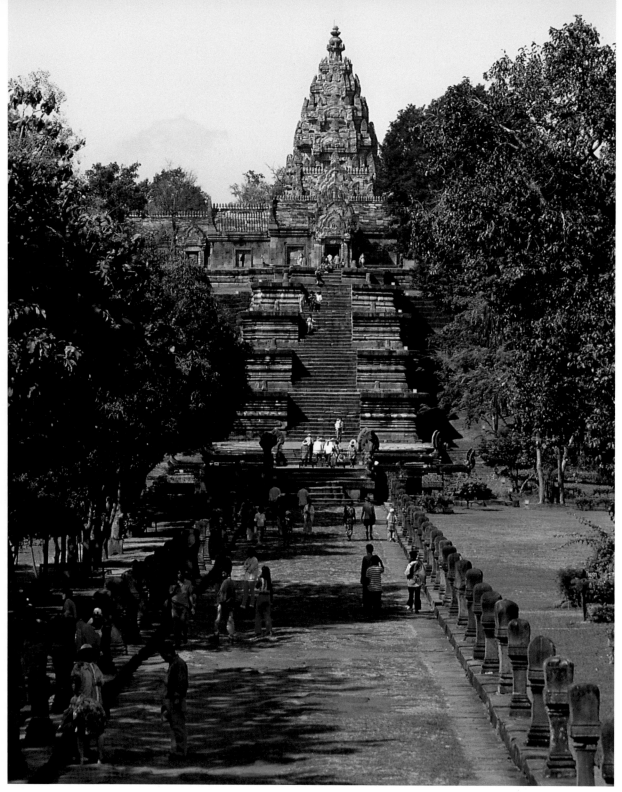

Above Prasat Phanom Rung, Thailand's largest temple complex of the Khmer period,
Central Eastern Province, near Laotian border

Opposite (top) Phi Mai, northeastern Thailand
(bottom right) Prasat Muang Tham, northeastern Thailand
(bottom left) Prasat Muang Tham, a northeastern Khmer temple ruin

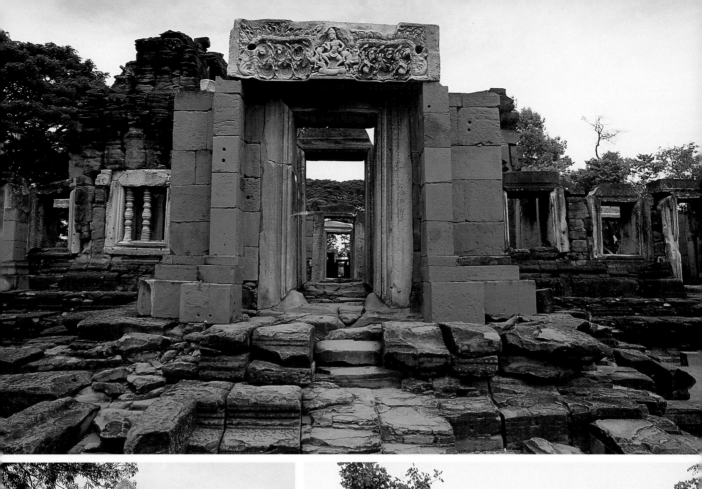

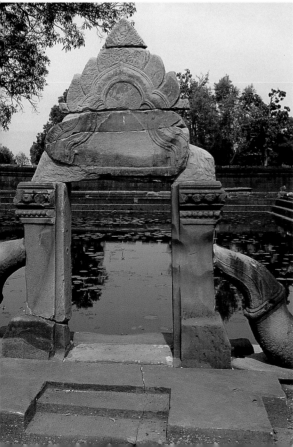

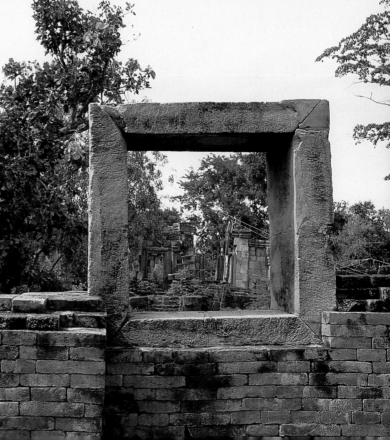

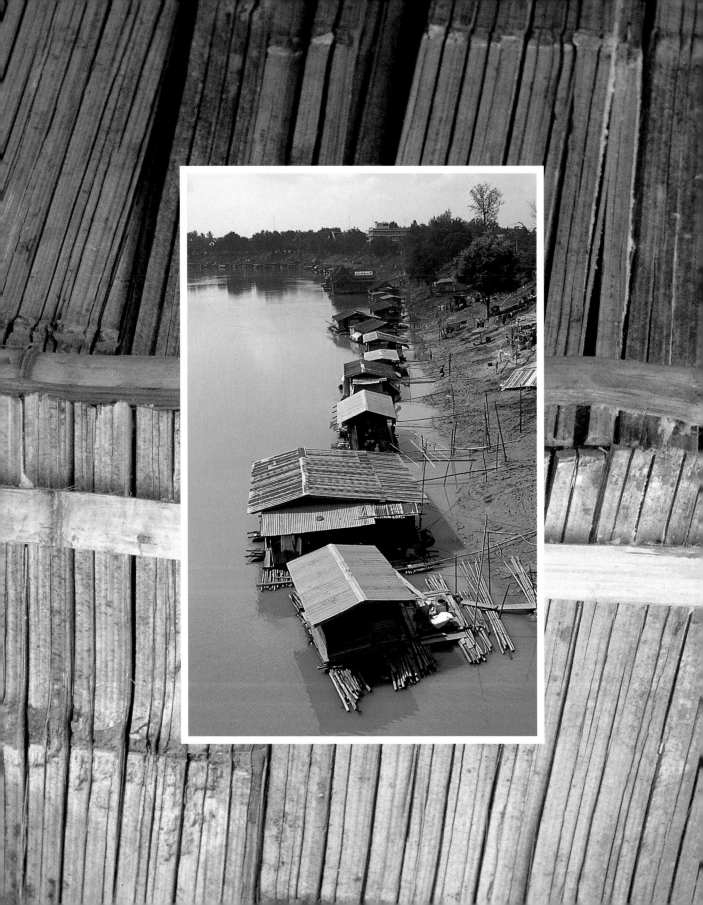

Opposite (inset) River dwellers, Phitsanulok
(background) split bamboo wall of an Akha house

Above Waterpot at a temple complex. Water is always available for the thirsty traveller

Following pages Clay Buddha images in the gardens of Wat Rajanadda,
constructed during the reign of King Rama III

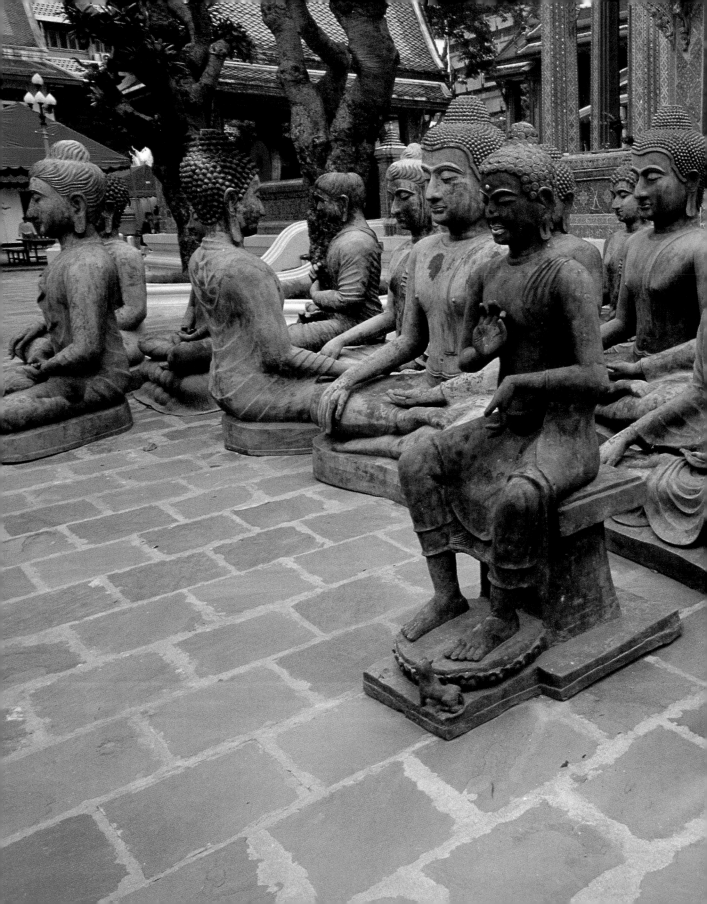

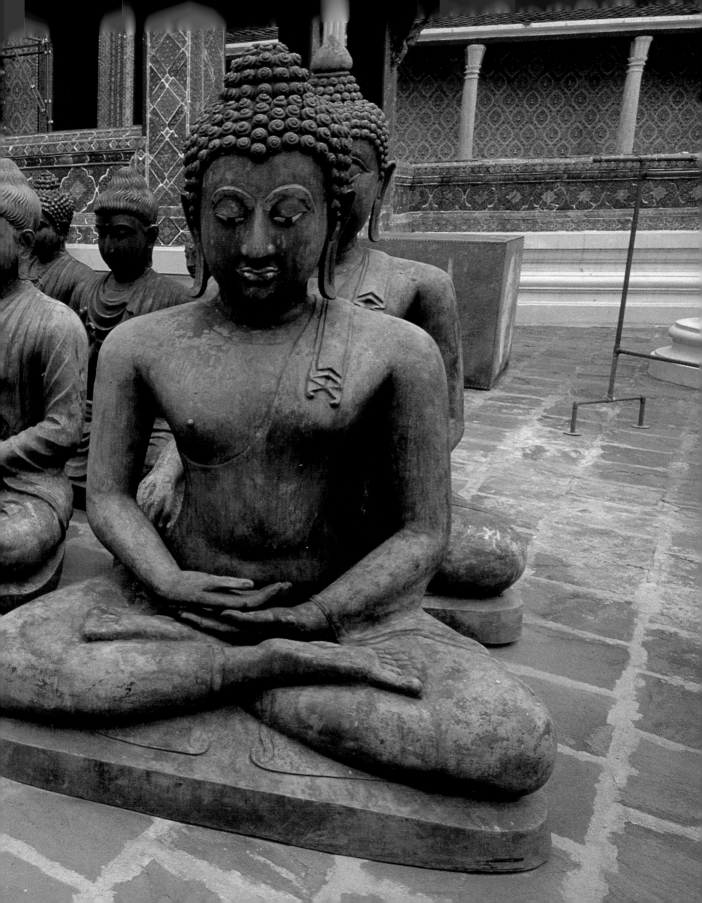

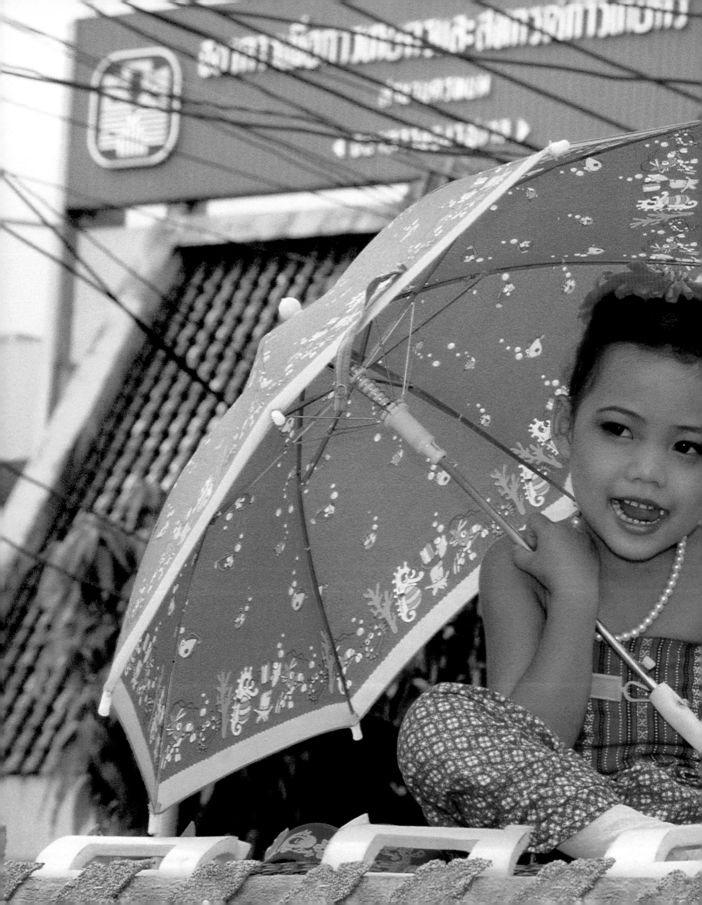

9.
Multicolour

Exuberance captured in a spectrum of colours. Sweet little girls in their best dresses and the prettiest flowers of every kind to be sported. Bunches of marigolds and lotus buds ready for temple offerings. The torsos of the *garudas* are a myriad of mosaic and inlay. Stuccoed temples sparkle with mirrors and painted surfaces. The Thais thrive on the variety of the colour spectrum. In the bright light of day, the sun shines from every exposed surface in rainbow-bursts of energy.

Two little girls at the Wax Boats Festival, Sakorn Nakorn, Isan Province, northeast Thailand

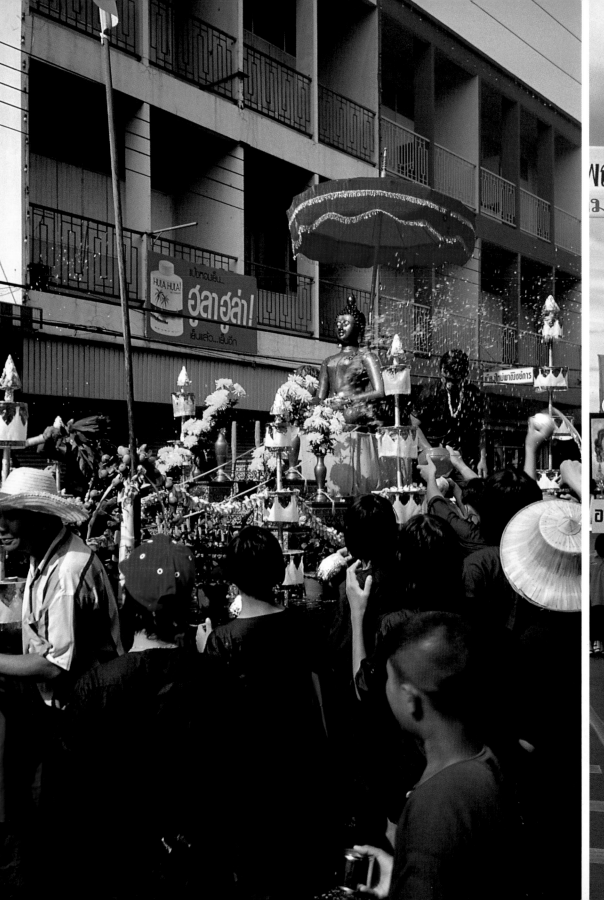
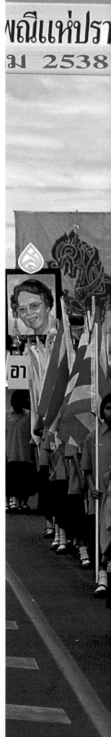

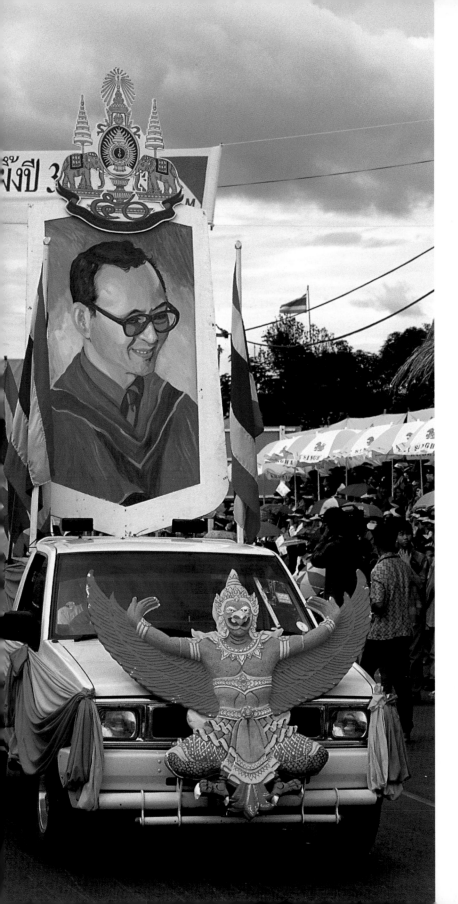

Left Street festival, Isan Province, northeast Thailand

Right Tribute is paid to King Bhumibol Adulyadej, during a procession in central Thailand

Following pages Stucco inlaid with mirrors and coloured glass

151

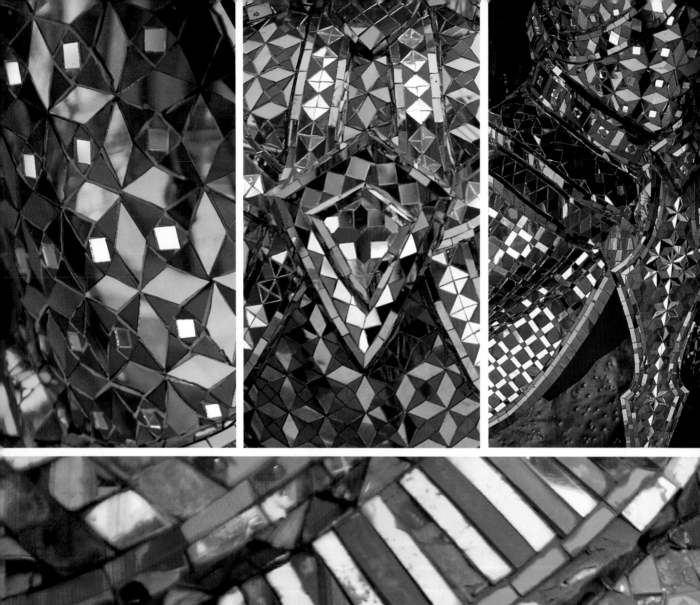
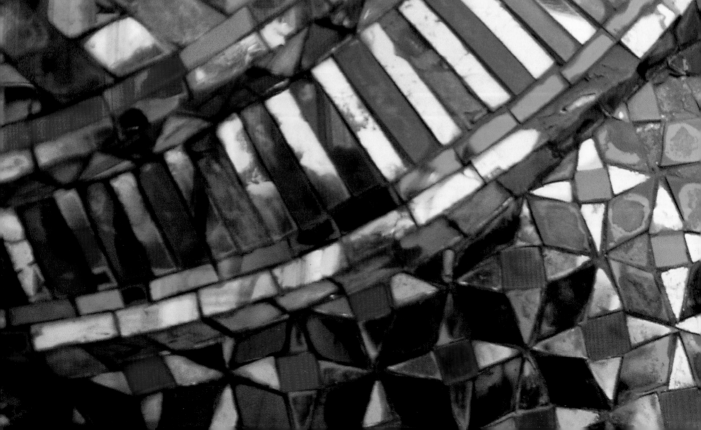

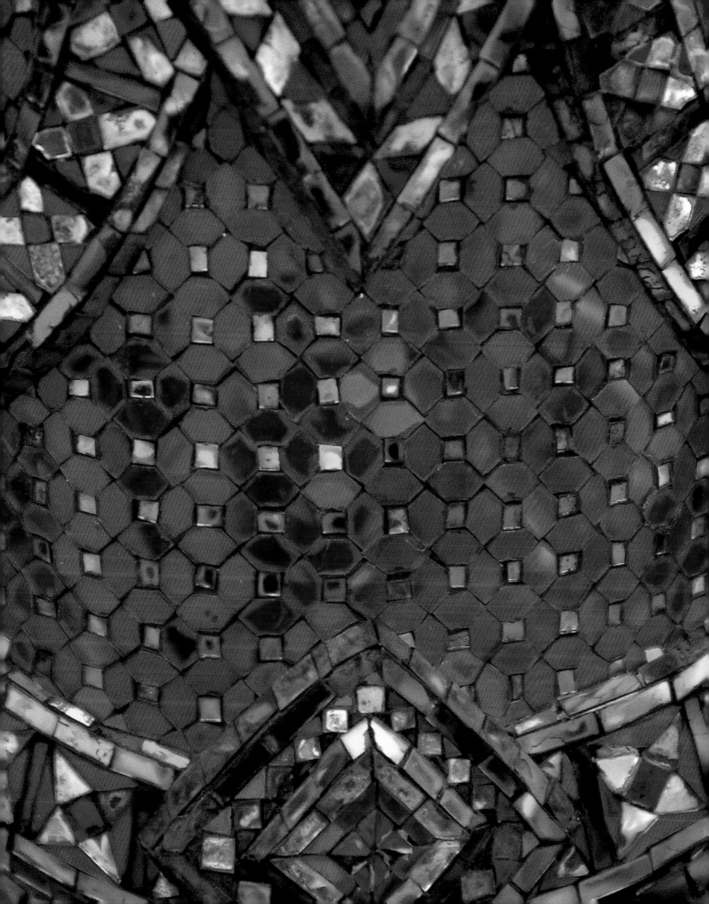

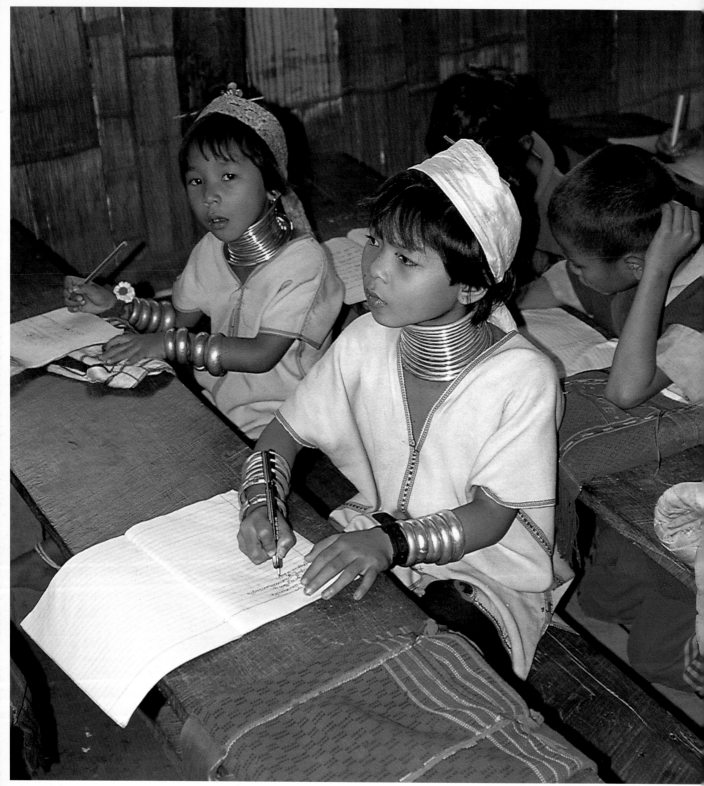

Above Long-necked Karen girls at school on the border of Myanamar, Northwest Province

Opposite Temple dancing girl, Sukhotai, during the Loy Kratong Festival, Central Plains

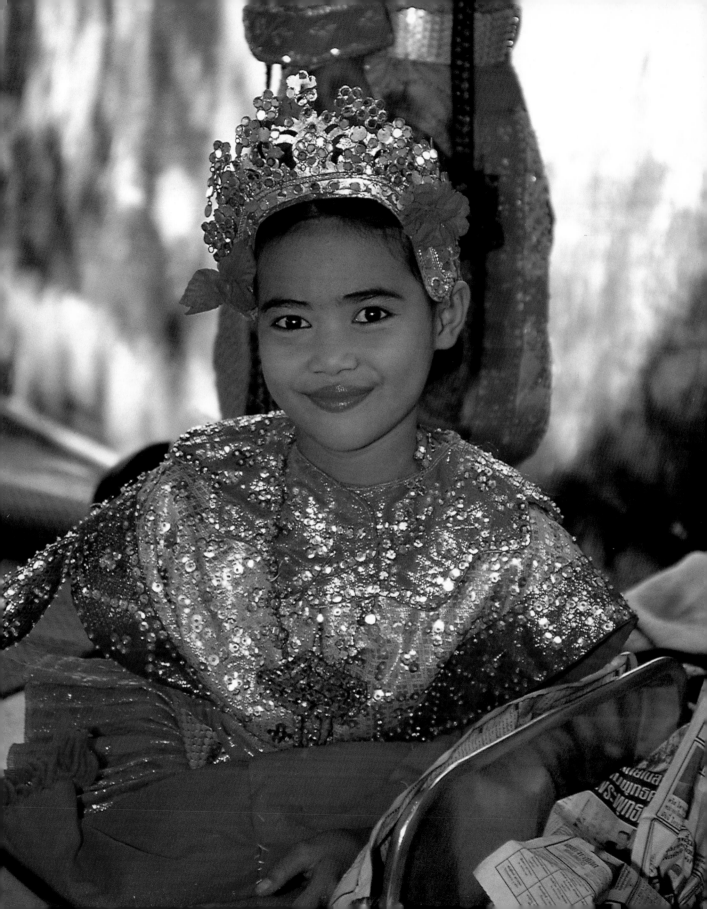

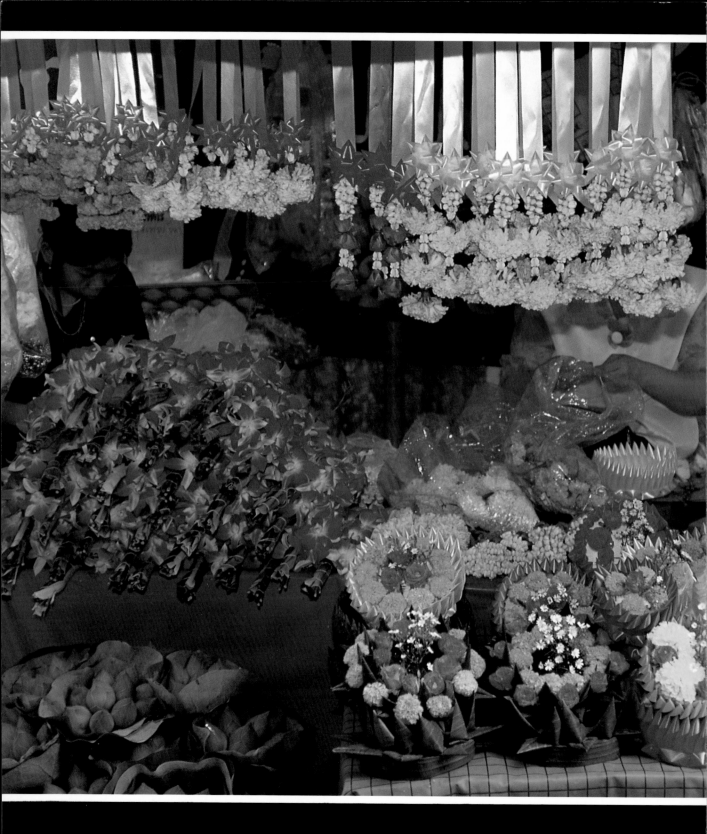

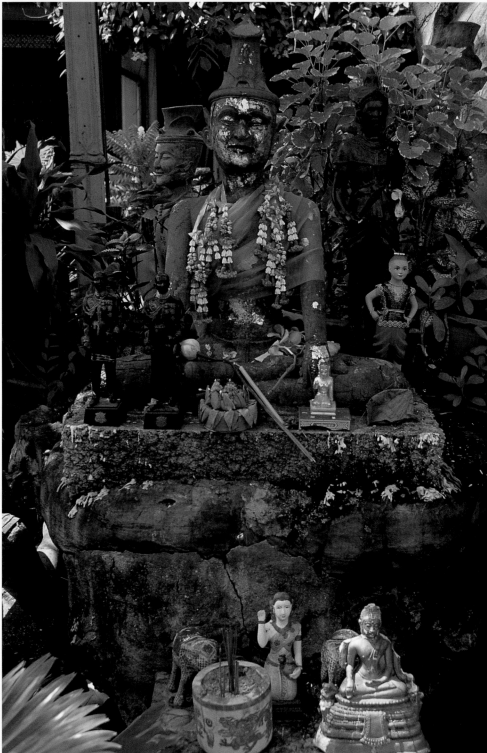

Opposite Temple offerings in the market

Above Antique stall with Buddha images and medallions at the Temple Festival market, Sukhotai

Following pages Tribal woman selling bunches of marigolds at the market at Nakorn Phanom, Isan Province, northeast Thailand

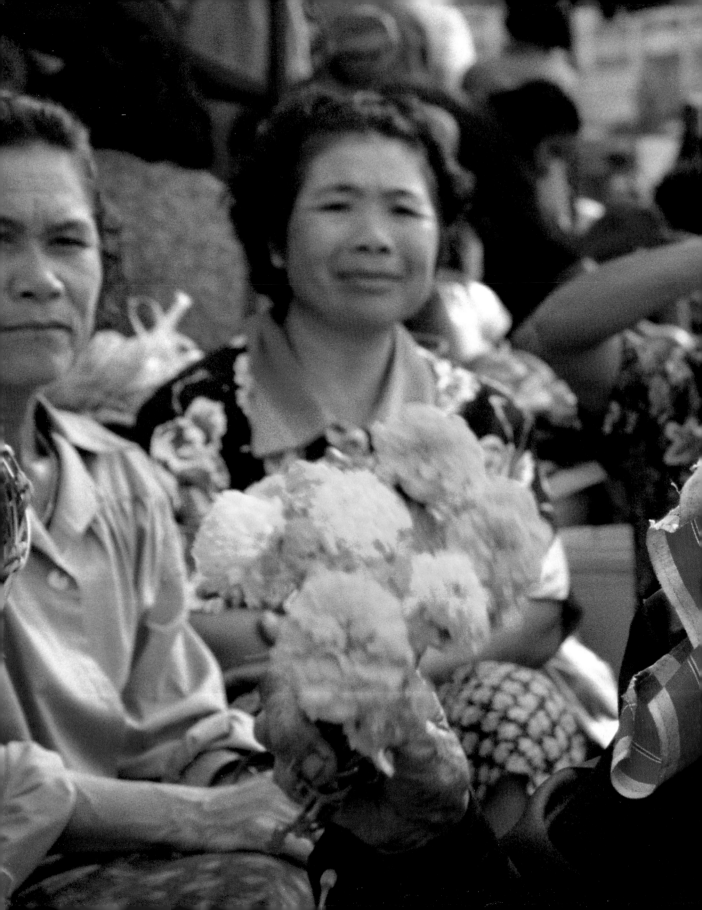

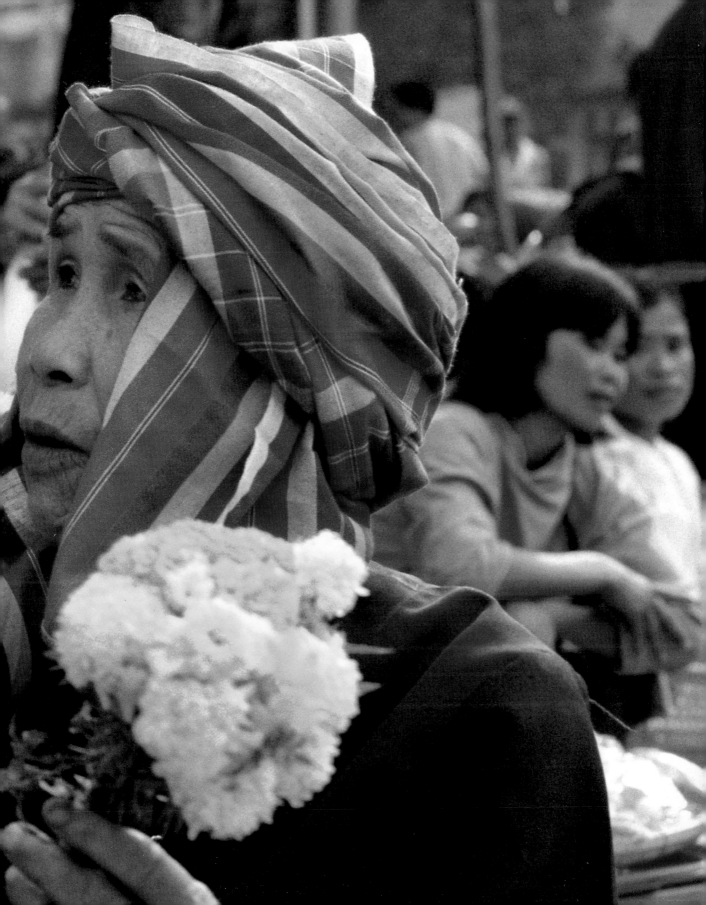

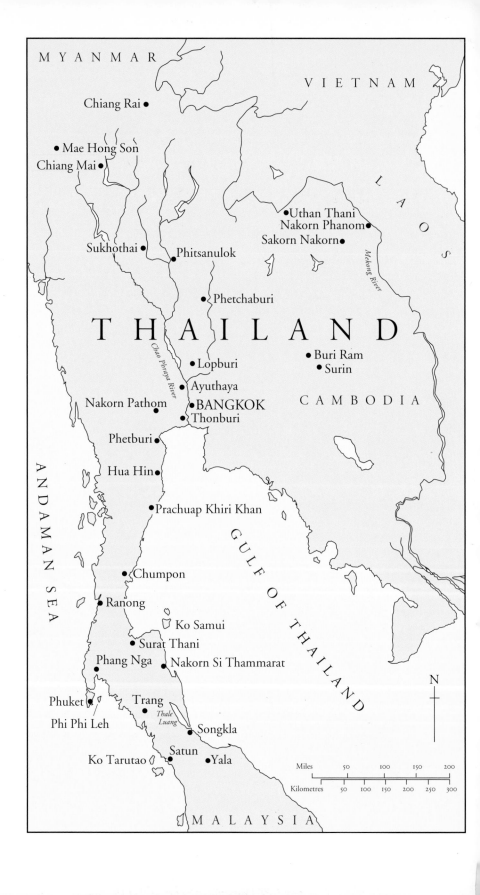

MYANMAR

VIETNAM

Chiang Rai

Mae Hong Son

Chiang Mai

LAOS

•Uthan Thani
Nakorn Phanom•
Sakorn Nakorn•

Sukhothai

Phitsanulok

Mekong River

Phetchaburi

T H A I L A N D

Chao Phraya River

•Buri Ram
•Surin

Lopburi

Ayuthaya

CAMBODIA

Nakorn Pathom

BANGKOK
Thonburi

Phetburi

Hua Hin

Prachuap Khiri Khan

ANDAMAN SEA

GULF OF THAILAND

Chumpon

Ranong

Ko Samui

Surat Thani

N

Phang Nga

Nakorn Si Thammarat

Phuket

Trang

Phi Phi Leh

Thale
Luang

Songkla

Ko Tarutao

Satun

Yala

Miles		50	100	150	200	
Kilometres	50	100	150	200	250	300

MALAYSIA